Look at me

PO. 3172
£32.00

Look at me
Photographs from Mexico City
by Jed Fielding

Introduction
Britt Salvesen

Essay
Vince Aletti

The University of Chicago Press
Chicago and London

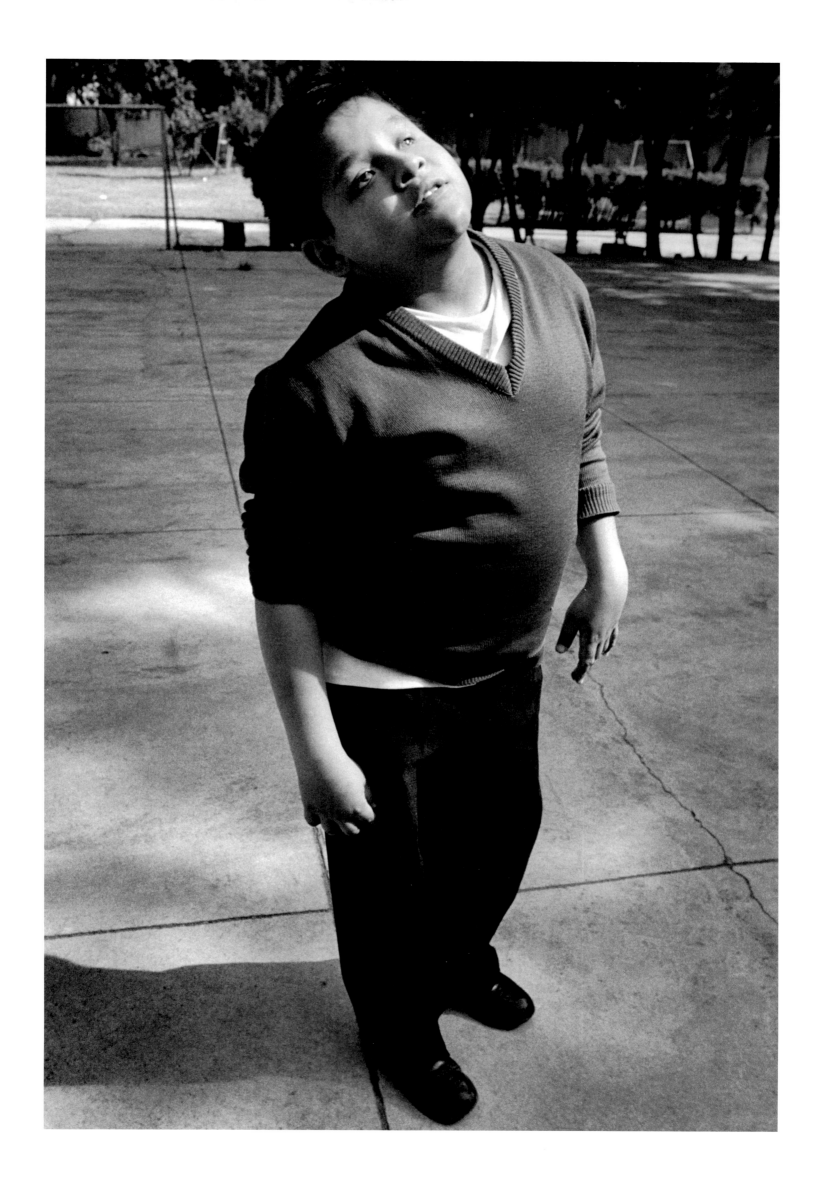

Contents

Jed Fielding is a Chicago-based photographer who works at the intersection of two traditions: the street photography we associate with Henri Cartier-Bresson and his successors, and the high modernist attention to design, surface, and light characteristic of Fielding's teachers, Aaron Siskind and Harry Callahan. For his first book, *City of Secrets: Photographs of Naples by Jed Fielding*, he made images of great energy and refinement from the displays of physicality, tenderness, and danger in Naples's poorer districts. Seeming to issue from the particular theatricality of life in the city's narrow streets, these photographs are nonetheless closer to portraiture than documentary – collaborative works, Fielding calls them.

The photographs in Fielding's new book, *Look at me*, extend his earlier themes in compelling ways. Collaborating now with blind children (and their parents and teachers), Fielding concentrated closely on the children's features and gestures, exploring the enigmatic boundaries between surface and interior, innocence and knowing, beauty and the grotesque. Although deliberately challenging and often disturbing, Fielding's work is ultimately affirming. One could say that the photographs confront disability in order to plunge us into sheer life.

"Disability," however, is a term that in this case may obscure more than it reveals. The children in these photographs attend some of Mexico's best schools for the blind. The teachers and administrators are proud of their institutions; they would otherwise not have welcomed Fielding on his visits. For many of the children, these schools provide their best chance to emerge from isolation. In other words, Fielding's photographs are not intended as exposés or works of advocacy. Like his Naples photographs, they are visual explorations of human vitality. In *Look at me*, that vitality extends beyond the limit of self-consciousness. In place of the theatricality of his Naples subjects, Fielding's new work shows us more essential gestures of absorption, more basic expressions of our creatureliness. These photographs achieve what only great art, and particularly great portraiture, can: they launch and then complicate a process of identification across the barriers that separate us from each other.

Fielding's photographs are extraordinarily arresting on the level of form. He is clearly the heir of his teachers Siskind and Callahan in his commitment to visual experimentation and the transformative potential of photography. At the same time, he is fearless in soliciting the ethical questions of his medium. What does it mean to photograph people – vulnerable people – who cannot look back, despite their proximity? Fielding poses the question, indeed harnesses it, without wanting to resolve it. As this work with the blind children progressed over several years, Fielding moved closer to his subjects and assumed increasing directorial control. For some of the children, these were

times of play or repose, for others (at least for a moment), of distress. Fielding has refused to condescend to these children, regarding them all as active participants in his project. These are images from which we sometimes want to look away, but that always come across as tender and deeply humane.

It was precisely as a humanistic exploration that this book of photographs caught the attention of The University of Chicago Press and persuaded us of its importance. We are grateful to our colleagues at Studio Blue, and especially to Jed Fielding, for working with us to publish *Look at me*.

Alan Thomas
Editorial Director for Humanities and Sciences
The University of Chicago Press

Introduction
Britt Salvesen

Jed Fielding's *Look at me* participates in a number of overlapping conversations relating to photography and representation. An in-depth pictorial study of blind children in four schools in Mexico City, the project – beginning with its title – is imperative, even confrontational, in nature. Yet Fielding offers respect while also demanding it. *Look at me* draws attention to (and distinctions between) the activity of sight and the consciousness of form. Many photographers assume the centrality of sight to their medium, even conflating the physiological with the mechanical, the eye and the lens. Rather than relying on such neat metaphors, Fielding has chosen a subject that bluntly poses the original question: what is vision?

The field of inquiry is at once philosophical, biological, aesthetic, and cultural. Jacques Derrida addressed it with reference to draftsmanship and depiction in *Memoirs of the Blind: The Self-Portrait and Other Ruins* (The University of Chicago Press, 1993). Martin Jay, like Derrida writing with reference to Western philosophical traditions, examined the contradictory implications of vision as a means of both enlightenment and oppression in *Downcast Eyes: The Denigration of Vision in Twentieth-Century French Thought* (University of California Press, 1993). And neurologist Oliver Sacks, in the case studies assembled in *The Man Who Mistook His Wife for a Hat: And Other Clinical Tales* (Summit Books, 1985), finds cause for wonder in the compensations and restorations that can occur when vision is lost or disrupted. We also understand blindness through study of the many historical and mythological figures for whom it is a defining characteristic: Homer, Oedipus, Polyphemus, Samson, Tiresias, Francisco de Goya, John Milton, Louis Braille, Helen Keller, James Joyce, Jorge Luis Borges, Ray Charles. Blindness is thus generously represented as a symbolic category but less often considered as a somatic reality.

This consideration is precisely what Fielding's project provokes. His intellectual curiosity ranges across the disciplines sketched out above, but it is his personal experience that invests his photographs with such force. Having forged his reputation as a street photographer in a contemporary humanist vein with his first monograph, *City of Secrets: Photographs of Naples by Jed Fielding* (1997) – an engrossing and energetic cumulative portrait of a distinctive city and its citizens – Fielding has honed his ability to engage in the delicate interaction necessary to establish a relationship between artist and subject. Time, touch, and talk can foster an exchange. Yet even with an ideal of trust, power remains an element in this negotiation. And in the Mexican schools for the blind, even more than in the streets of Naples, daunting obstacles presented themselves. Fielding found himself not so much grasping for a translation from one language to another (which assumes that equivalent terms exist for a single idea) but seeking transcendence from one reality to another (which acknowledges an existence apart from the material world, where ideas may take nonverbal forms). Pushed by these

particular subjects beyond the customary contract of trust, he had to arrive at a more elusive covenant of mercy: he had to acknowledge, and avoid exploiting, his power over them more explicitly and carefully than ever before.

But the result is not an idealized depiction; the people in Fielding's photographs are neither storied heroes nor wise biblical elders. They are, crucially, children, and he makes no attempt to tame their wildness or contain their feral energy. They are crazy, cranky kids in dusty dungarees; they are pudgy pre-teens wearing their Sunday best; they are hormonally charged adolescents flaunting fashion fads. Finally, they are not picturesque, angelic charity cases, and by rejecting this formula Fielding also declines to solicit the viewer's empathy in any conventional way. Instead, he forces us to confront the uncomfortable assumption, common to many folk traditions, that blindness is an affliction, if not an outright punishment. E. T. A. Hoffman gives us one exemplary narrative in this vein. In "The Sandman," an adult protagonist recalls his nurse's frightful description of the story's titular figure: "He is a wicked man, who comes to children when they won't go to bed, and throws a handful of sand into their eyes, so that they start out bleeding from their heads. He puts their eyes in a bag and carries them to the crescent moon to feed his own children." The children in such stories, and in the Mexican schools, are vulnerable to injury, deceit, prejudice. Are we able to perceive in them countervailing strengths, to cast them in roles other than that of victim or martyr?

These photographs initiate a new perspective by portraying children as individuals, not simply as the category of the blind, but across a broad emotional and experiential range, and in the here and now. In an even more revealing move, Fielding's own growth – his relinquishing of assumptions, overcoming of fear, embrace of beauty – can be read in every frame. He can neither mask his fascination nor romanticize it. Without tracing a journalistic or chronological narrative of his visits to the schools over the years, he implies a trajectory along a complex emotional scale. Perhaps Fielding felt (as the viewer may feel) an initial ambivalence like that described by the poet Charles Baudelaire. This keen observer of nineteenth-century Parisians, from the prosperous bourgeoisie to damaged outsiders, crafted a powerful verbal image of blind men in *Flowers of Evil*: "Behold them, my soul: they are truly frightful! like mannequins, vaguely ridiculous, terrible, singular as sleepwalkers, aiming their darkened orbs who knows where." Dread and revulsion, as so often in Baudelaire, scarcely conceal his futile yearning to comprehend an altered state. The poem concludes: "But, more bewildered than they, I ask, All these blind men, what are they looking for in the sky?"

The fixation of the sighted on the inaccessible world of the blind is effectively a quest for self-knowledge; in literature, not always a noble

one. Baudelaire asks the question that H. G. Wells presumes to answer in his ambiguous morality tale "The Country of the Blind." In this story, an explorer called Nunez finds himself stranded, after a mountaineering accident, in a remote Ecuadorian village whose entire population has been blind for fourteen generations. Quickly taking note of the way they have shaped their environment for safety and even comfort, he nonetheless assumes he will have the advantage over them. However, he finds "it tax[es] his nerve and patience more than he had anticipated, that first encounter with the population of the Country of the Blind." To his chagrin, the villagers deem him to be primitive, in need of instruction. "His senses are still imperfect," says one. "He stumbles, and talks unmeaning words. Lead him by the hand." Power struggles, both intellectual and physical, ensue; at the story's conclusion, Nunez (having fallen in love with a blind girl) has agreed to sacrifice his sight and commit himself fully to the community. Taking one last look at the mountain landscape, however, he loses his nerve and makes his escape. Wells leaves it to the reader to assess the protagonists – not only Nunez, but also the inhabitants of the Country of the Blind – for their cowardice, courage, or simple conformity to human nature.

Fielding has no such didactic or dramatic intent, but he does echo Wells in depicting an alternate world. A degree of disorientation, the photographer's own perhaps most prominently, animates many of the pictures. For in taking authority with his vision and his camera, he also learned to relinquish it. He disclosed his desire to understand, while acknowledging that unbridgeable gaps separate his experience from that of the children. Communication, that taken-for-granted American buzzword, emerges here as an urgent, necessary act, requiring and rewarding the kind of creative vision practiced by Fielding. And community, an equally cherished but usually abstract social ideal, is presented with tangible, heart-rending immediacy.

This impact derives in large part from Fielding's craftsmanship, which can be attributed to his education under Aaron Siskind and to his own respect for the material traditions of photography. His gelatin-silver prints are rich, deep, and totally absorbing. As objects, they point toward the medium's essence. Looking at Fielding's images, we are reminded of what happens in the darkroom, where an image magically emerges from a seemingly blank sheet of paper. In that moment, the unsettlingly reversed tones of the negative are converted into a legible positive; what was confusing suddenly makes sense. We can only imagine, or grope toward, an analogy to the blind person's revelatory perceptions through touch. The camera may be an equivalent to the eye, but it can concede the mysterious power of other senses and subjectivities. Much more than a metaphoric rumination on blindness, Fielding's *Look at me* is a demonstration of photography's capacity to envision in ways that go beyond sight.

Look at me
Vince Aletti

"Look at me," Jed Fielding instructed the blind children in these pictures, and they would turn their faces toward his voice, his presence. Hearing him, sensing him, they could probably tell us more interesting things about this photographer than anyone else. I can only tell you what I know.

Fielding, who was born in Boston in 1953, says he knew he wanted to be a photographer at age fourteen. He came to that conclusion in a roundabout way. What he really wanted to do was draw, but he had little talent for it. His eighth-grade art teacher suggested that sketching from magazine photographs rather than from life might trigger a breakthrough, and it did indeed: once Fielding decided to take his own photographs instead of relying on existing images, he never went back to drawing. In the beginning, he says, "I photographed everything. I was doing landscapes and still lifes and portraits and a lot of nudes. I wanted to be a photojournalist. I wanted to work for *Life* magazine."

In his freshman year at the Rhode Island School of Design (RISD), he confided that goal to Aaron Siskind, whose brief stint as a professor there (1971–75) coincided exactly with Fielding's years as a student. Siskind promised, "I'll cure you of that shitty idea," Fielding recalls. "Aaron convinced me to become an artist, and, with my personality, he was right. In one conversation, we became instant friends." Fielding's course was set. Studying with Siskind and another legendary photographer and RISD professor, Harry Callahan, changed his life.

Even before Fielding graduated, Siskind had become not just a teacher and a mentor, but a colleague and a confidant – someone Fielding trusted to give him an honest answer when he needed to know exactly where he stood as a photographer. In his junior year, he asked Siskind a simple, terrifying question: "Am I doing anything?" Siskind responded, "No, you're not." He told Fielding that all the good landscapes, nudes, and portraits he had been making did not really amount to much, and that if he really wanted to live up to his potential, he should be working in the street. Fielding began his first real street work in earnest later that year when he and Siskind traveled together to Peru to photograph. "I started working in a foreign country for the first time, and it was incredibly exciting. That was that. Everything I've done with my life came out of that trip."

Fielding's approach to street work draws on his musical, theatrical, and athletic talents. Trained as a musician, he is accustomed to "thinking rhythmically, from left to right. I tend to think of photographs almost as a musical score. When I'm on the street, I'm moving people around and placing them the way a composer would place notes." Because photographing on the street is "almost like being on stage,"

"I tend to think of photographs almost as a musical score. When I'm on the street, I'm moving people around and placing them the way a composer would place notes."

his background in theater in junior high and high school gave him another sort of edge: "I was used to people watching me. I wasn't embarrassed at being looked at. It became almost a performance. If you were shy, you couldn't do this. And I'm not shy." He's not slow, either. Siskind had admired Fielding's speed and decisiveness, and they served him well on the street. "It's like playing basketball in a way," Fielding says, "especially in a city like Naples, where you're trying to avoid getting mugged while you're photographing. You're concentrating deeply on picture-making, while constantly being aware of your surroundings."

Naples is the setting for Fielding's 1997 book, *City of Secrets*. Following a visit in 1977, he worked on its notoriously dangerous streets on and off over a period of thirty years. He went there for the same reason he had also begun photographing in Mexico: "I'm tremendously drawn to Latin culture. I love the people, I love the warmth, I love the theatricality of it." Naples had more drama than Fielding was sometimes prepared for, but it was endlessly seductive. It was there that he evolved his method of photographing in public: a physically close stance that constantly invades a subject's personal space. Because in Mexico he could not speak Spanish and initially had no Italian in Naples, Fielding developed a physical, gestural way of communicating that almost served as a common language. As a result, his Naples pictures have a rude vitality and a quality of comic grotesquerie that are truly Fellini-esque. We're thrust face-to-face with characters (including a number of children in gangs) we're not sure we'd like to run into after dark. But Fielding met them all head-on, and, working fast, gave no ground. "I always think of the street photography as a collaboration between me and the person being photographed," he says. "There's a quick level of intimacy that could not be achieved with physical distance." There's no sentiment in his results, but plenty of sometimes wary, sometimes helpless, affection.

The project that is now titled *Look at me* brought Fielding back to Mexico in 1998. Photographing in four different schools for the blind in Mexico City, he gradually developed a gentler, less aggressive stance and a looser, more expressive style. Although Fielding approached the material not as a documentarian but with the idea that its inherently surreal qualities would dictate the results, the circumstances under which he worked also forced him to adopt a new process. "There's something paradoxical, almost preternatural, about a blind child staring into a machine whose only purpose in the world is to see," he says, "and this fits into the history of the modernist aesthetic – an aesthetic to which I subscribe completely." But how that notion would manifest itself in the images he made was far from clear when Fielding started. At all the schools, he worked in outdoor

spaces – small parks, courtyards, enclosed playgrounds – and in natural light. He began by photographing the children at play but was happier with his results when he was able to work more intimately with one or two students. "As I continue with a project, as I get more comfortable and the subjects get more comfortable," he says, "I tend to get closer and closer."

Released from class to be photographed, the children were excited and full of pent-up energy, but they tended to scatter and collide when they were playing on their feet. Fielding, who had started bringing black fabric to mask the dull concrete walls and pavement, spread the material on gymnasium mats on the ground and let the kids play there side by side. "When something would happen that I really liked, I would just ask them to stop moving. I could photograph two heads or I could photograph the children in any number of combinations because they were lying down and could be still." Many of the pictures he made have no clear sense of orientation – no horizon, no up, no down. The children exist in their own universe, their broad, sightless faces like moons and bright planets filling and overflowing the frame. These are images that echo the aesthetic of Surrealism and the classic avant-garde: fraught, irrational, startling, and utterly subjective. Not documents but dreams, and sometimes nightmares.

The children's expressions run the gamut from delight to alarm, but they are uniquely unguarded. "These are very happy, well-cared-for children," Fielding is quick to emphasize; it was a challenge to get them to stop laughing in front of the camera. But he was constantly aware that he was responding to gestures and expressions that they had never seen or prepared. They had no public, camera-ready faces, only open, wonderfully changeable expressions that Fielding shaped, exaggerated, or softened with plays of shadow and light. Conscious that he was working with material that can shift in a second from ravishing to disturbing, he has been careful to control the printing process in the darkroom. "I want the work to be enigmatic and unsettling without crossing the line into the outrageous," he says. "One of the ways I try to keep that balance is by printing these pictures very richly and beautifully. Being respectful of tradition doesn't necessarily make you a traditional photographer."

Because his subjects could not see him, Fielding could not gesture to them as he might with people on the street. He used simple phrases in Spanish – "Look up," "Look down," "Come into the sun," "Look at me" – but when it came to positioning the children, he had to reach out and touch them. The kids were always touching one another and their play could be "ferocious," but it could also be sweet, casual, and caressing. Fielding, in directorial mode, realized that his own gentle prods were mimicking the way the children touched each other. The intimate physicality of this process has left its mark on the photographs, which are at once delicate and intense, joyous and troubling, mysterious, and full of life.

"There's something paradoxical, almost preternatural, about a blind child staring into a machine whose only purpose in the world is to see, and this fits into the history of the modernist aesthetic – an aesthetic to which I subscribe completely."

Plates

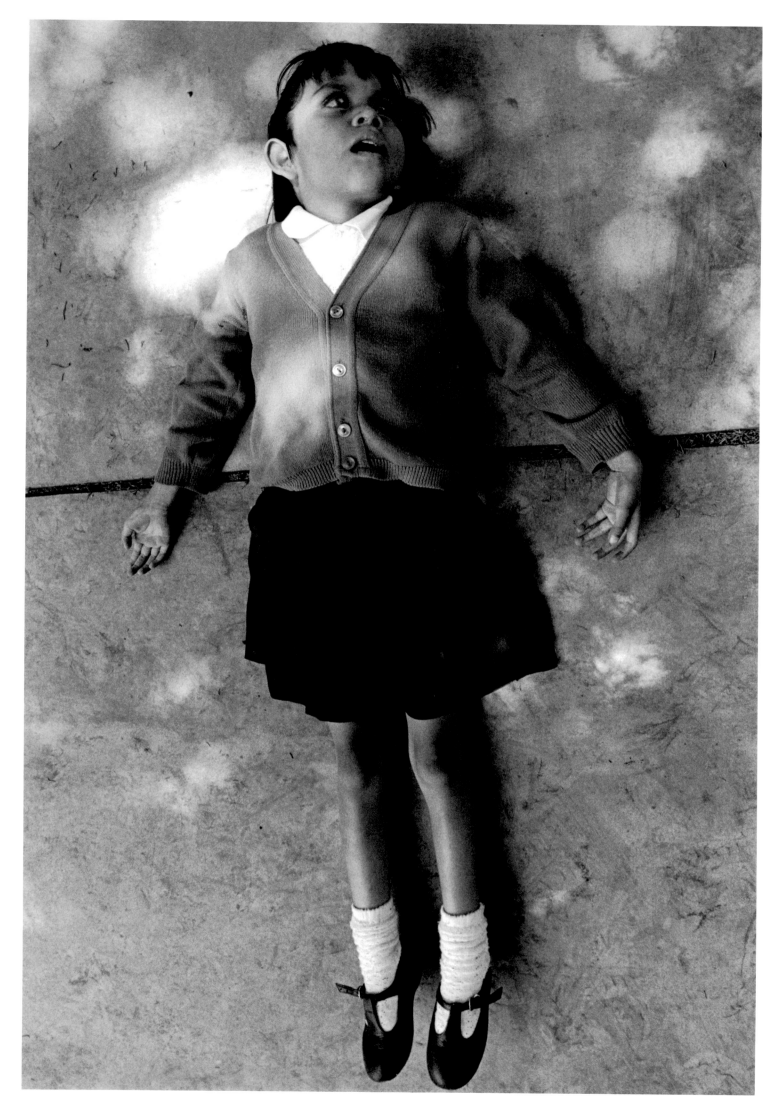

Plate 1 1999

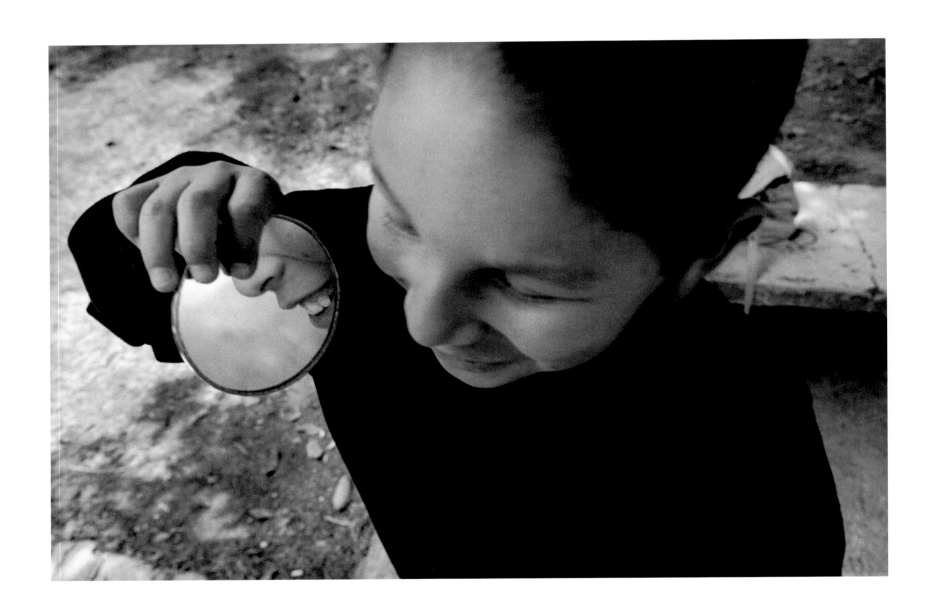

Plate 2 1999

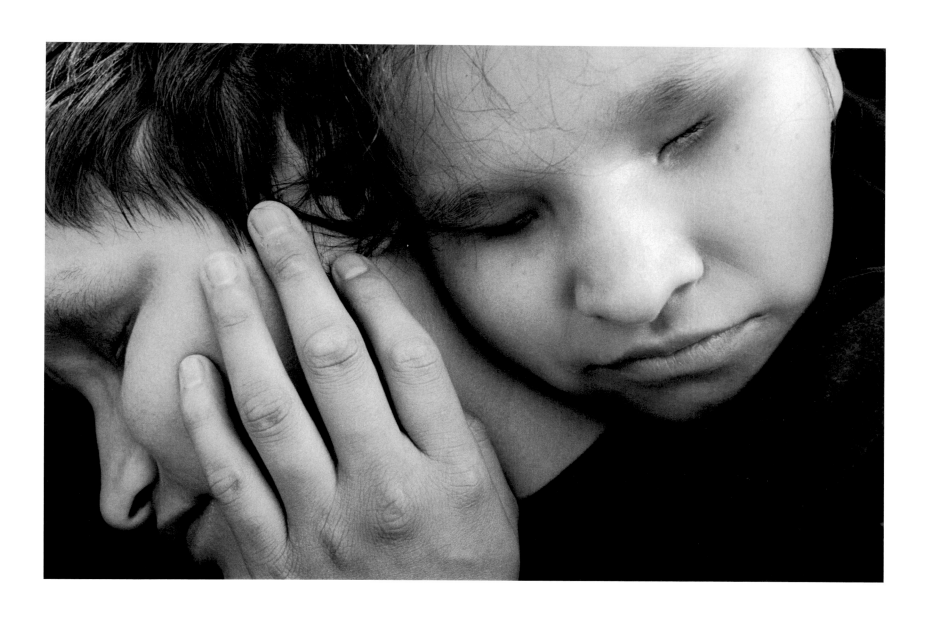

Plate 3 2003

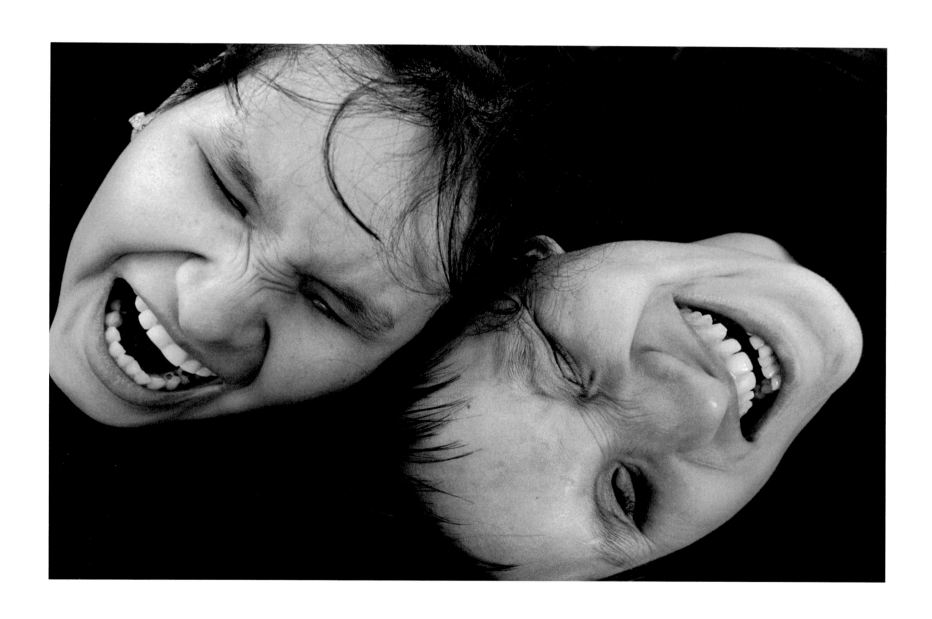

Plate 4 2003

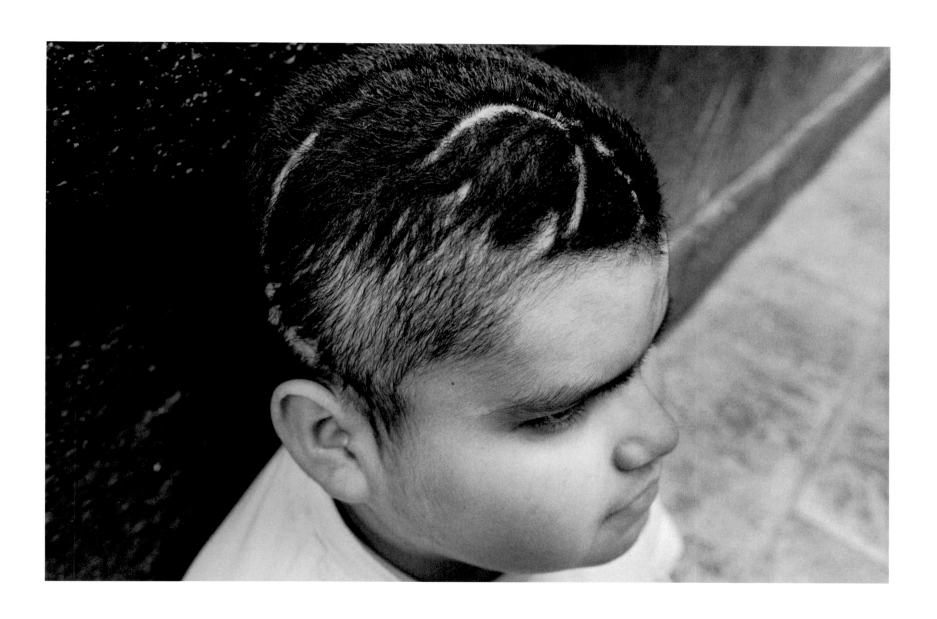

Plate 5 2001

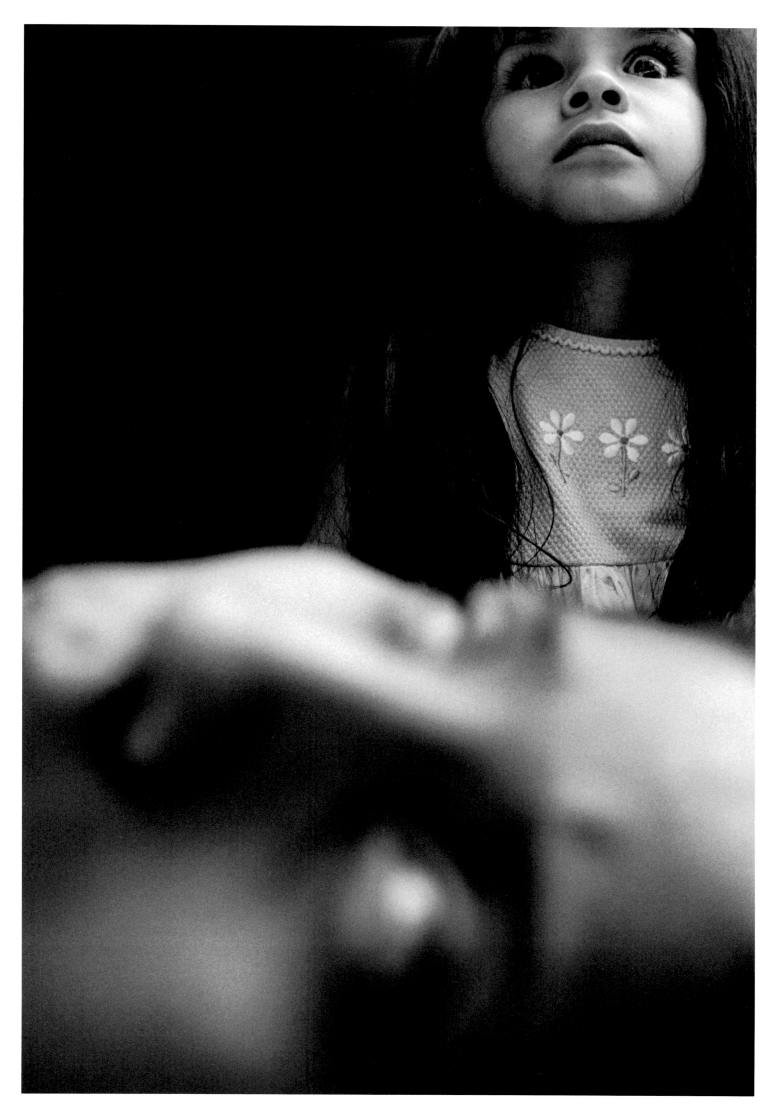

Plate 6 2003

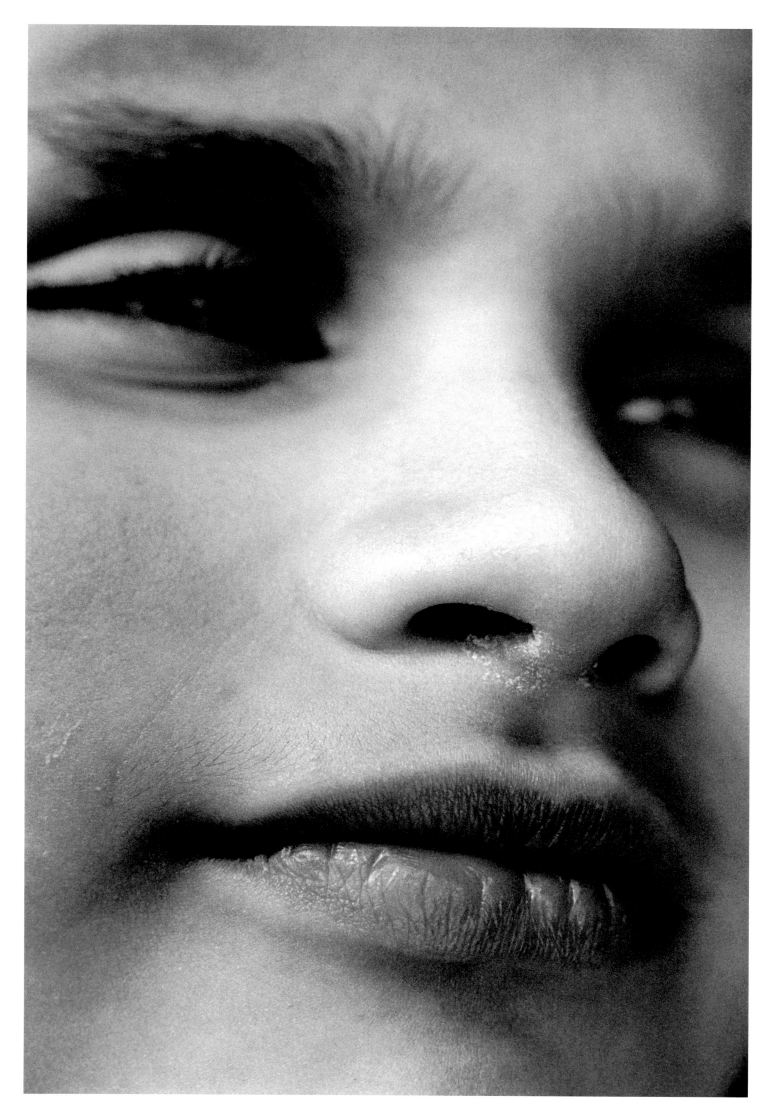

Plate 7 2005

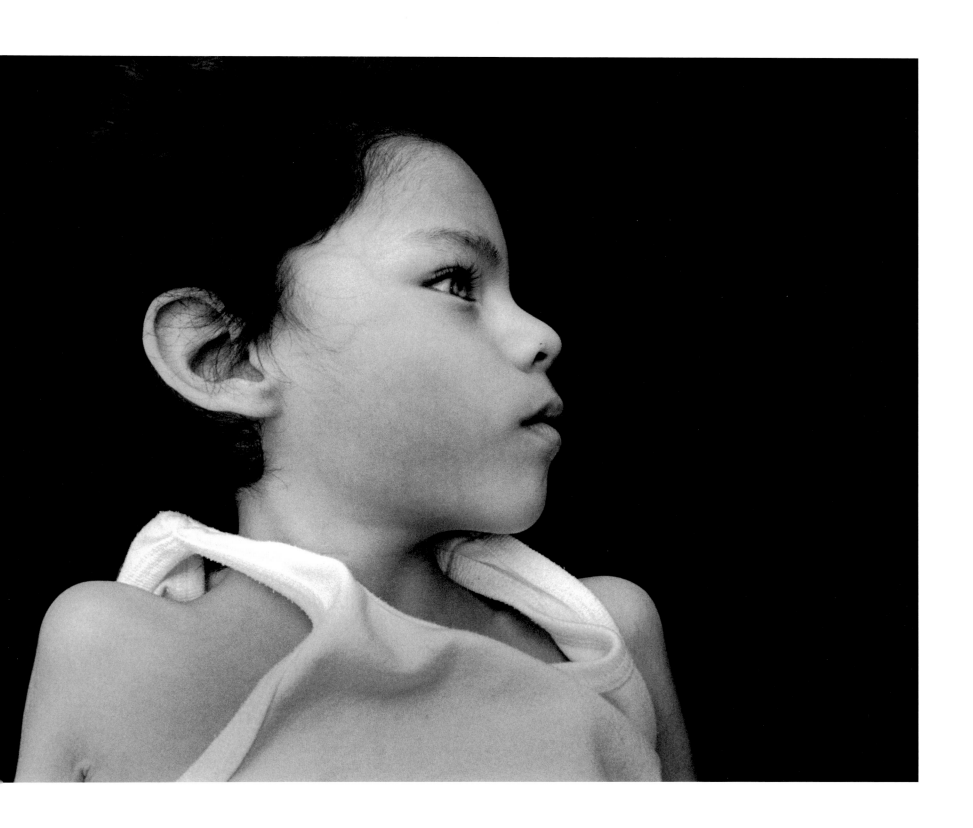

Plate 8 2003

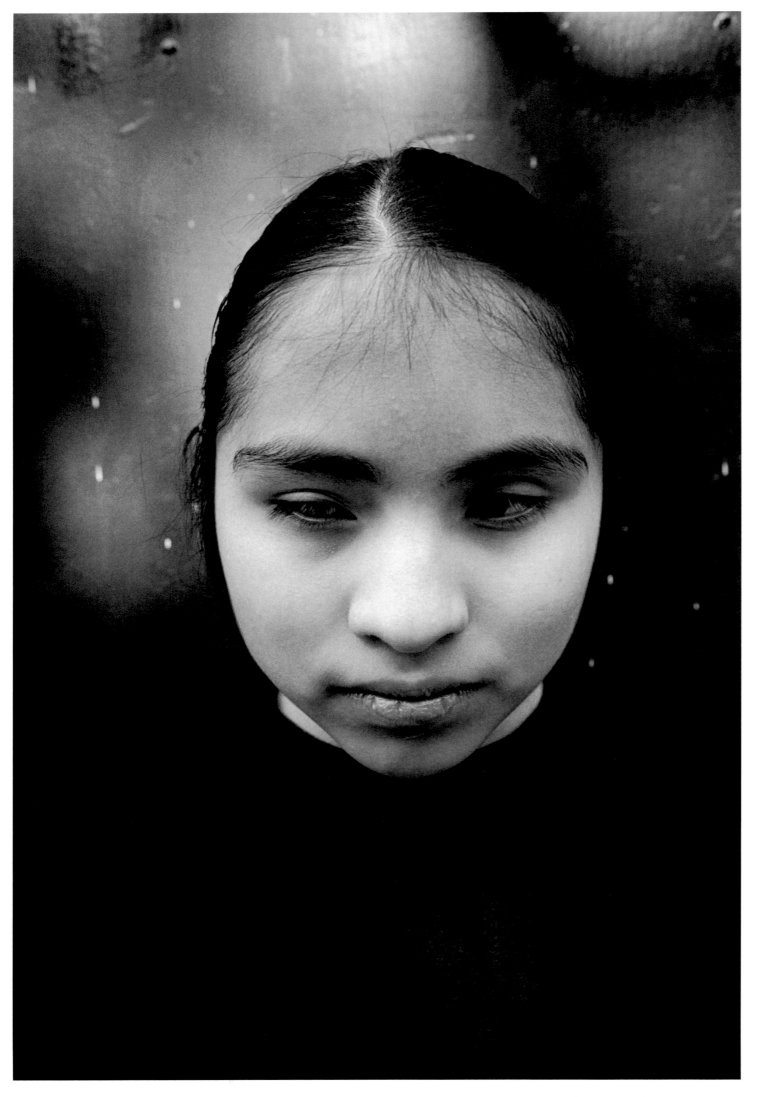

Plate 9 2000

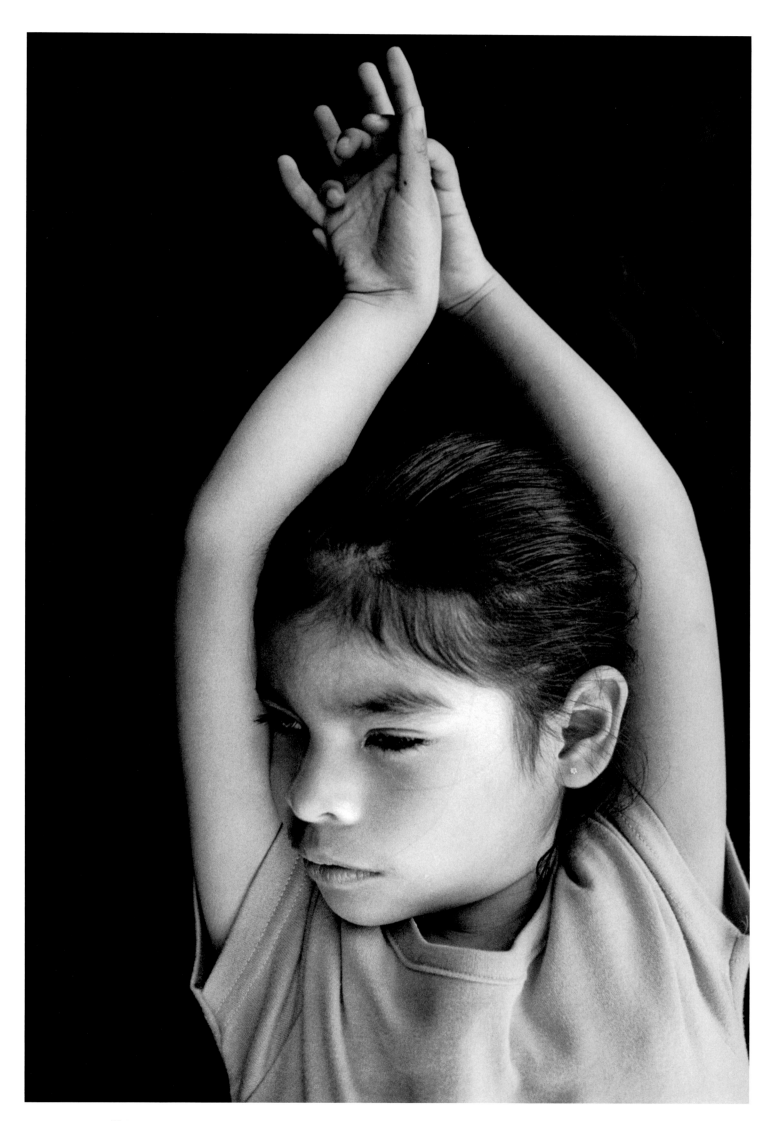

Plate 10 2002

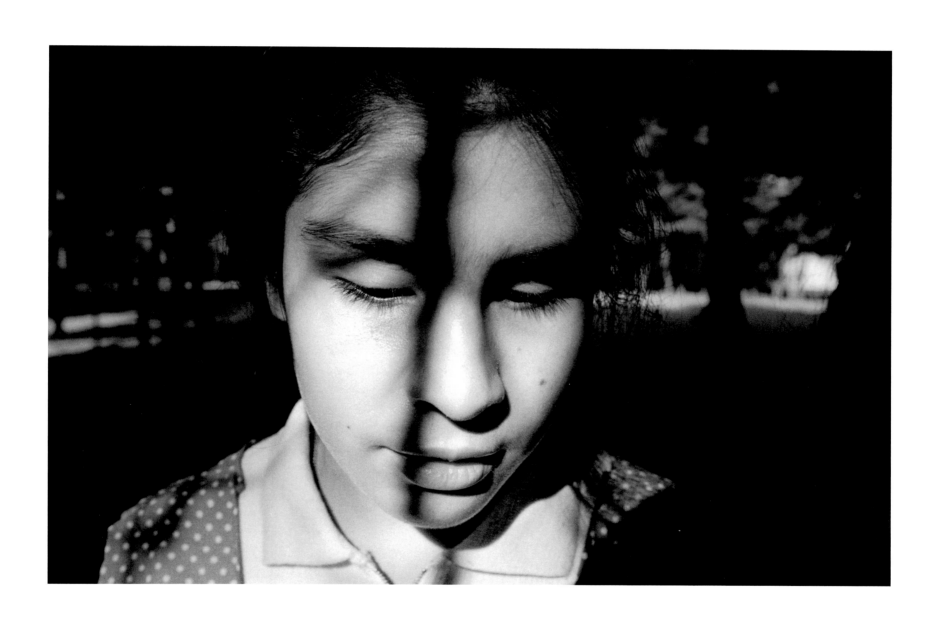

Plate 11 1998

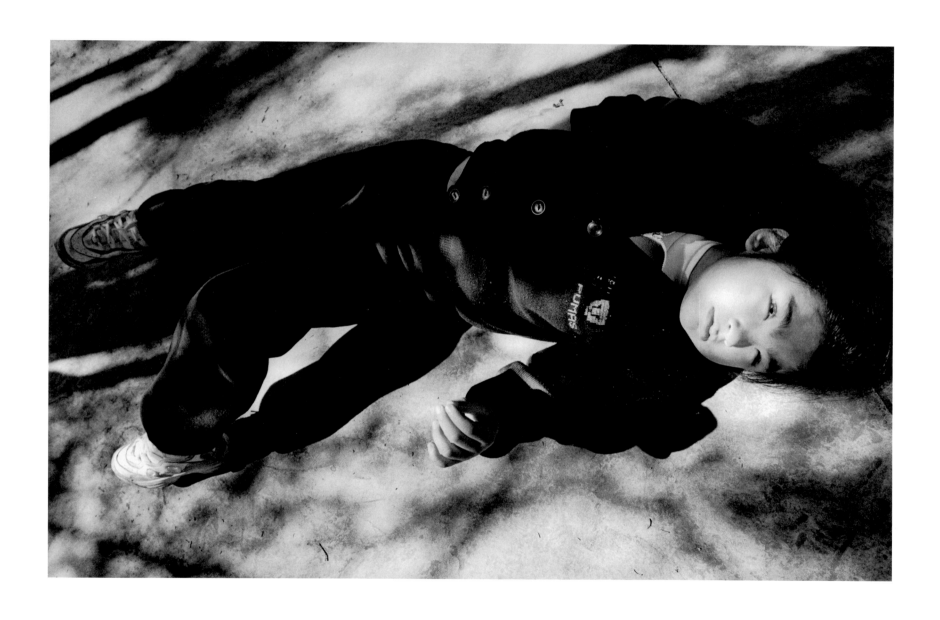

Plate 12 1999

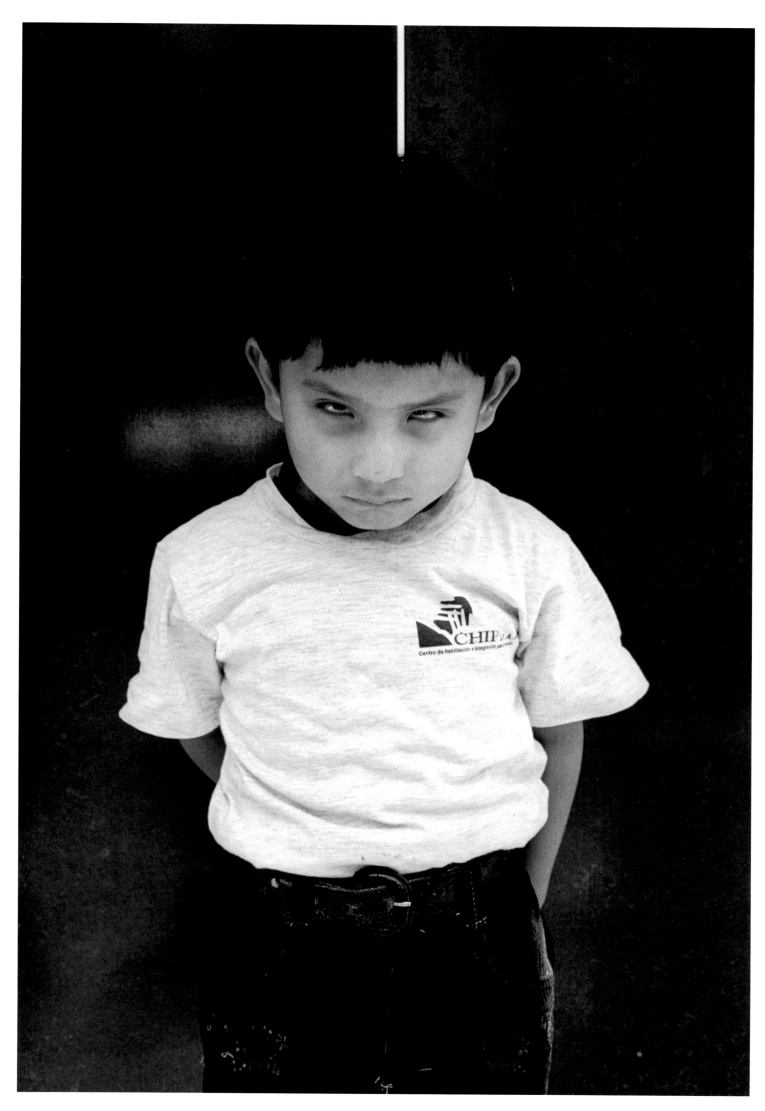

Plate 13 2000

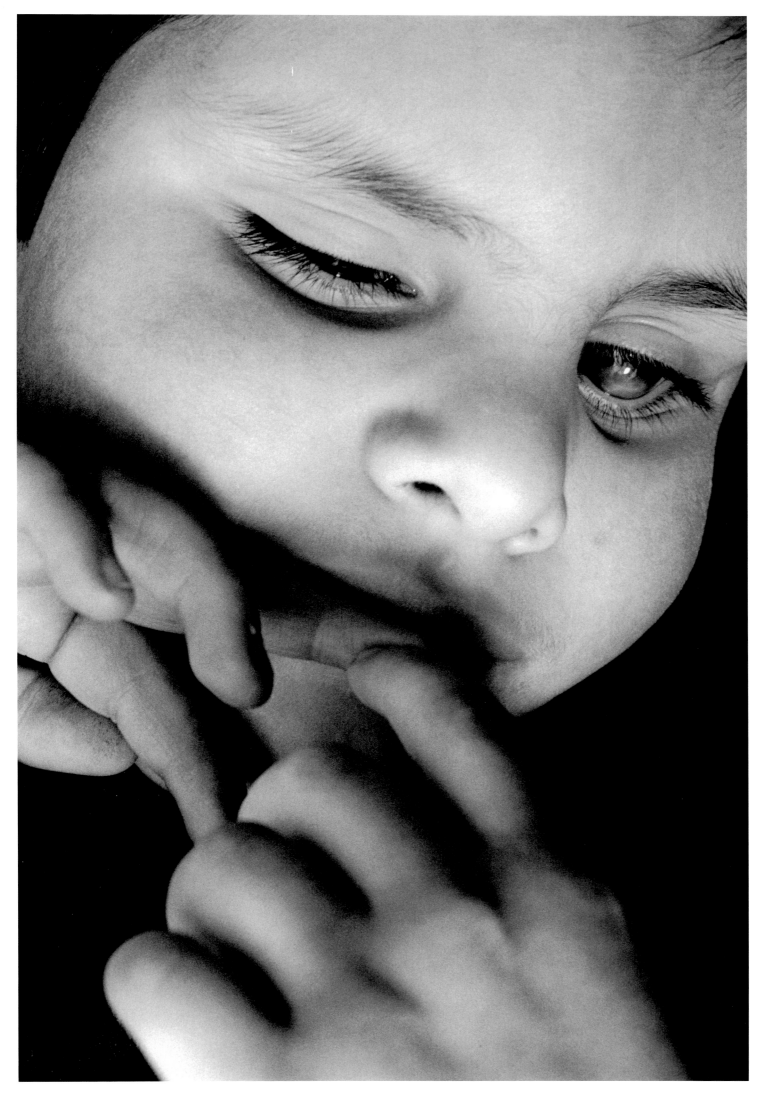

Plate 15 2005

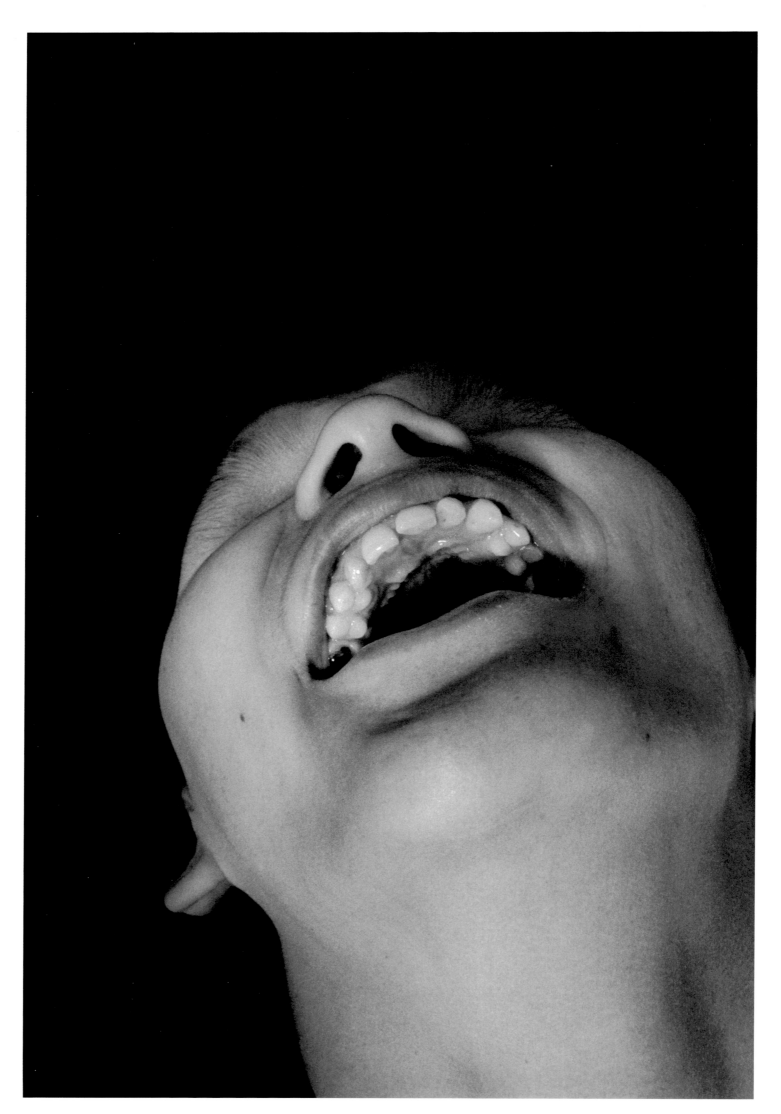

Plate 14 2003

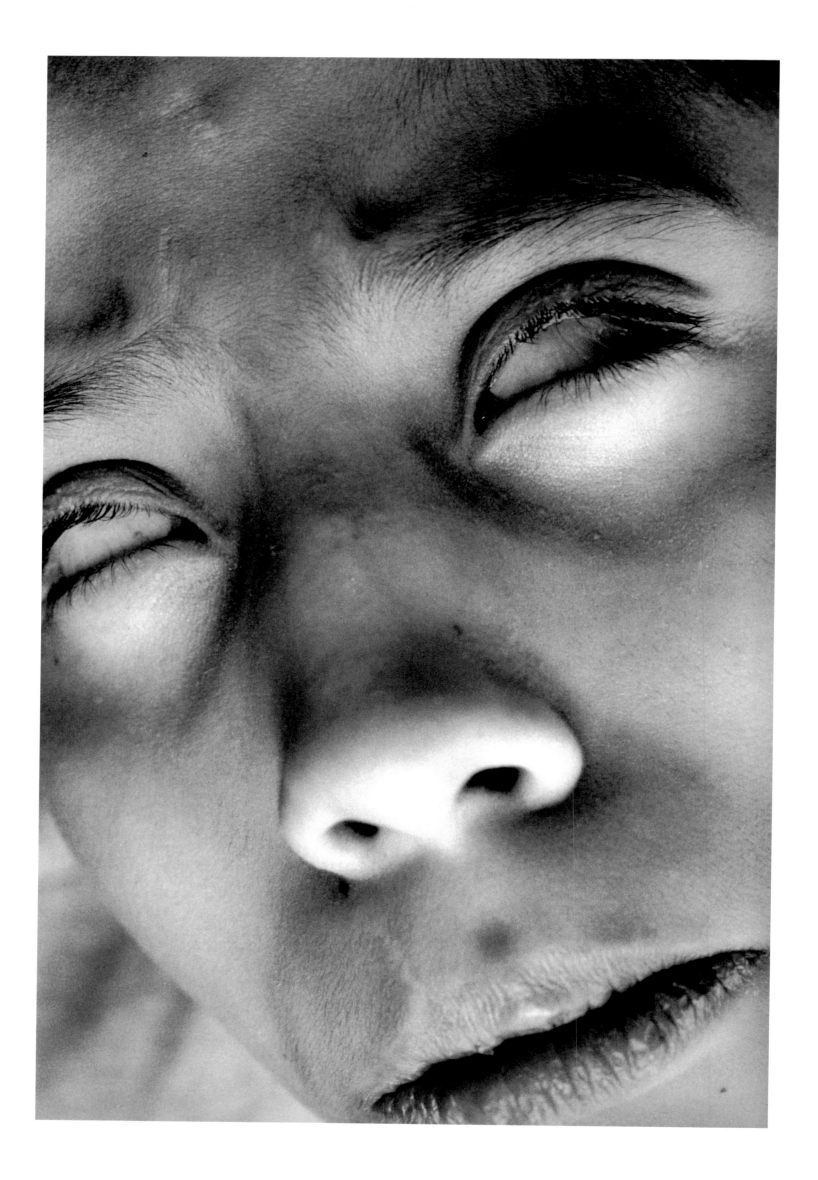

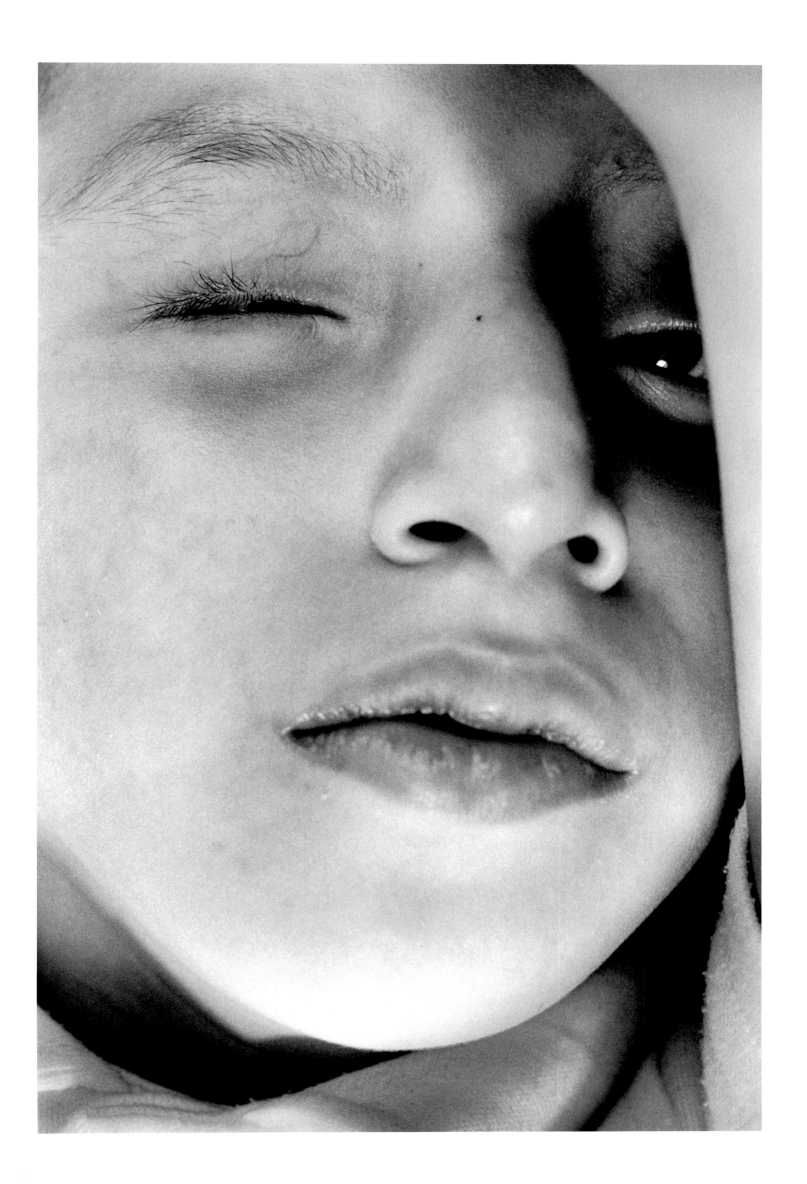

Plate 17 2002
Plate 18 2003

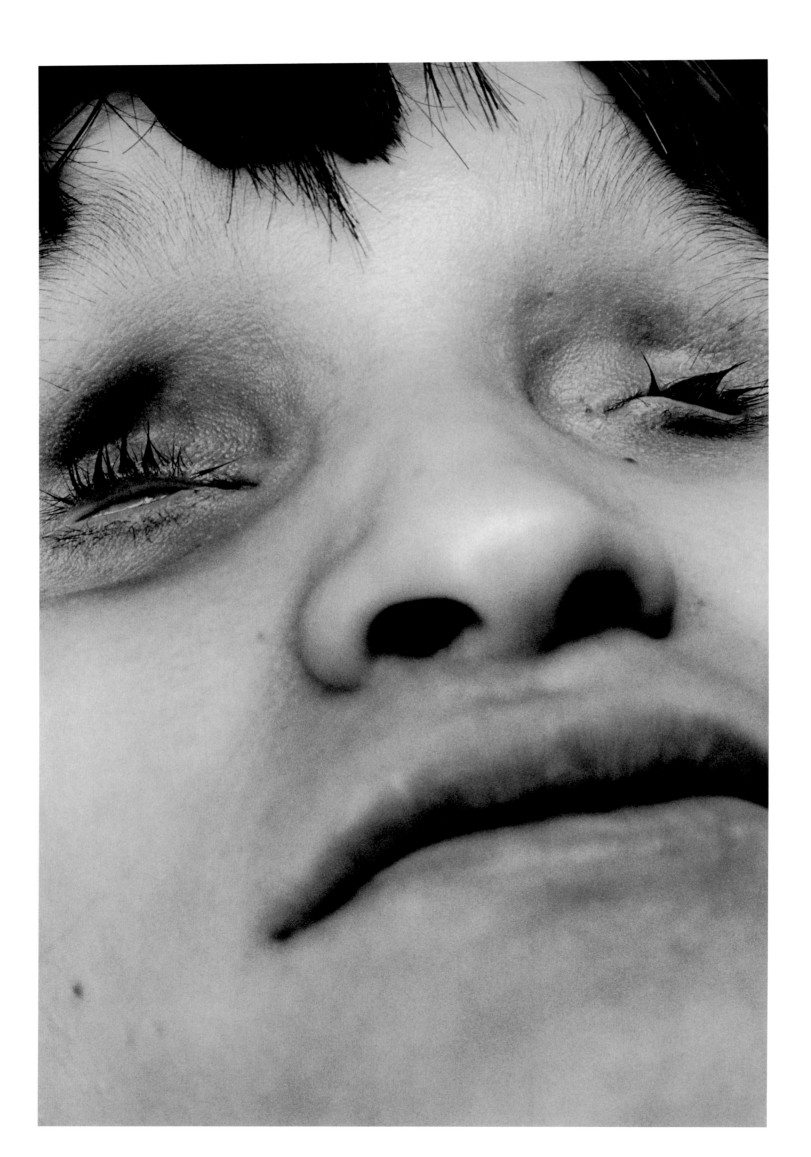

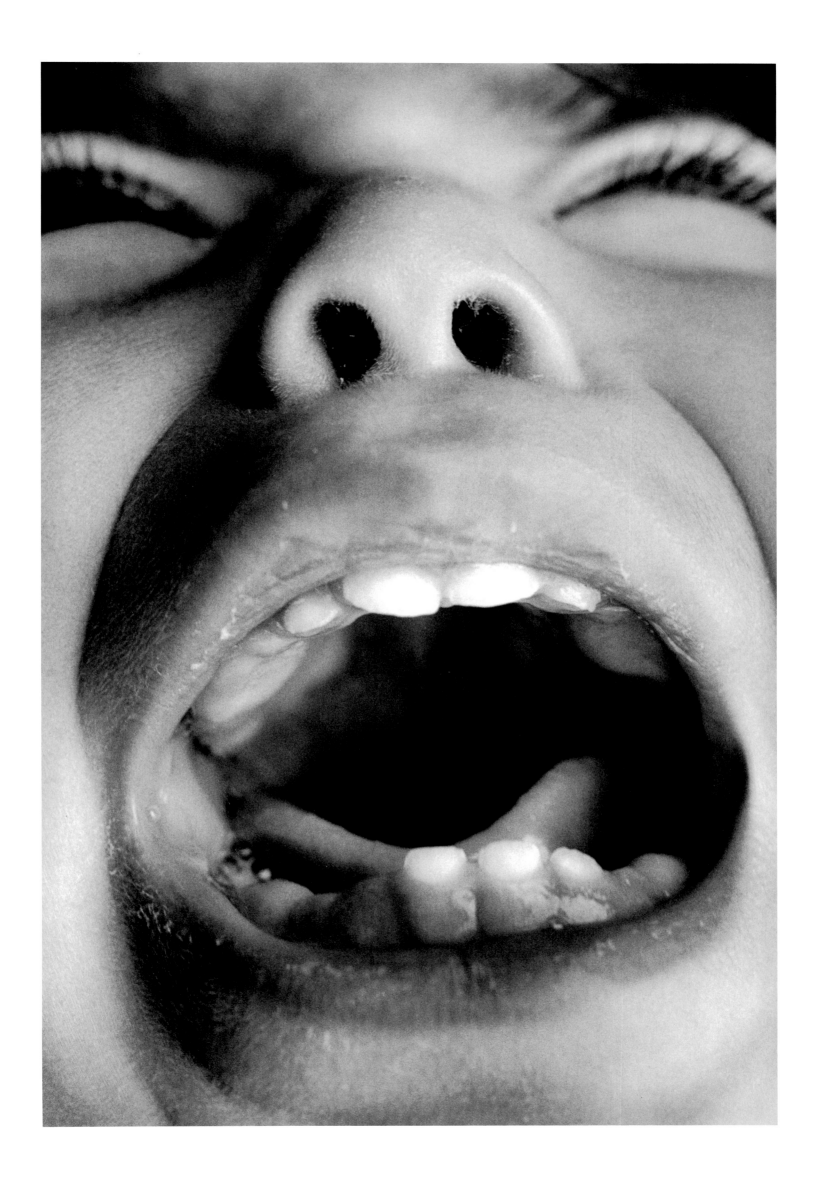

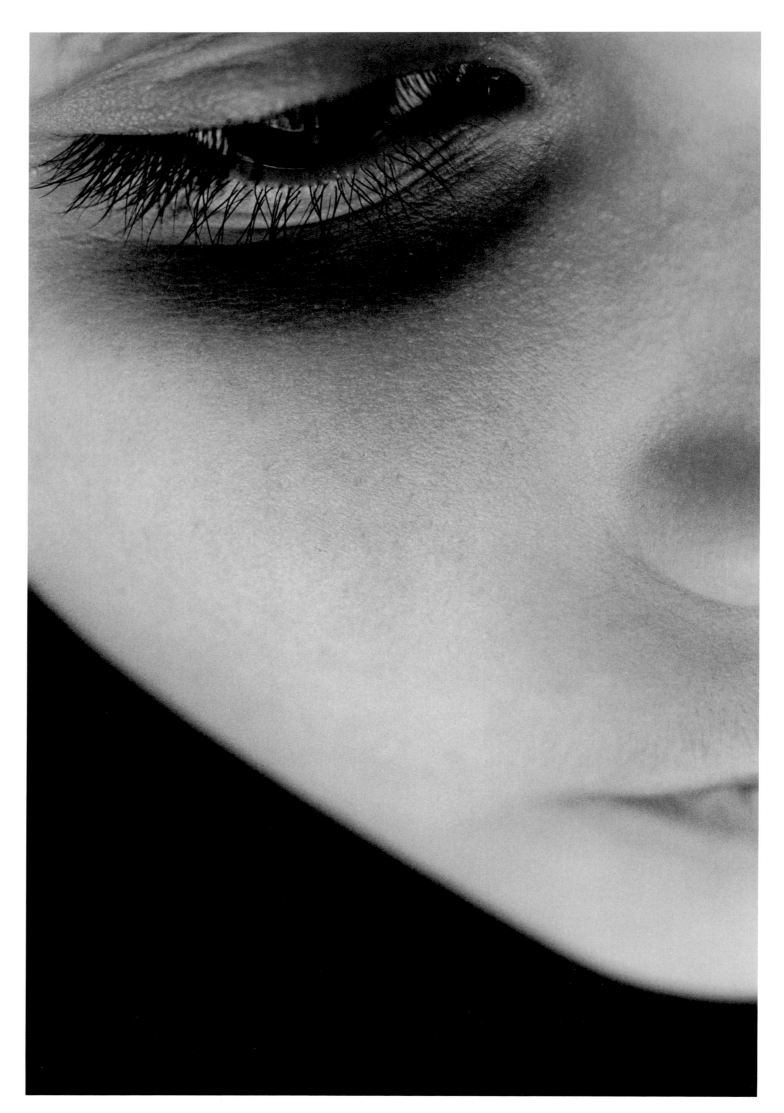

Plate 16 2005

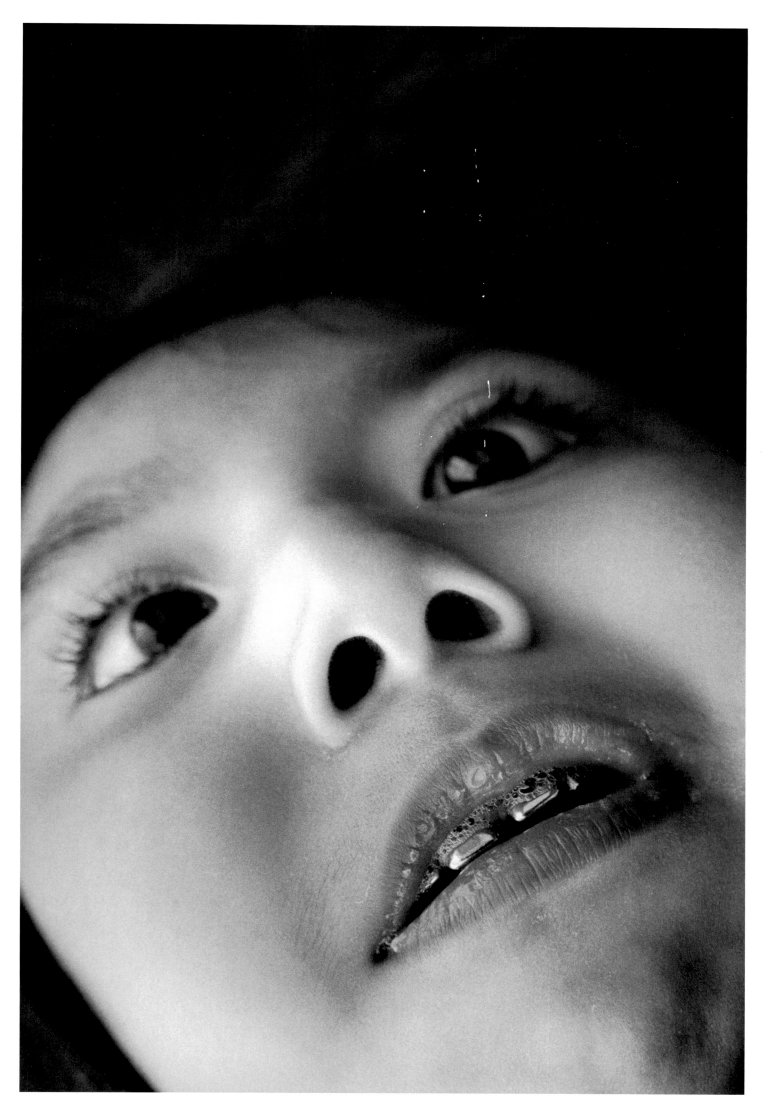

Plate 21 2002

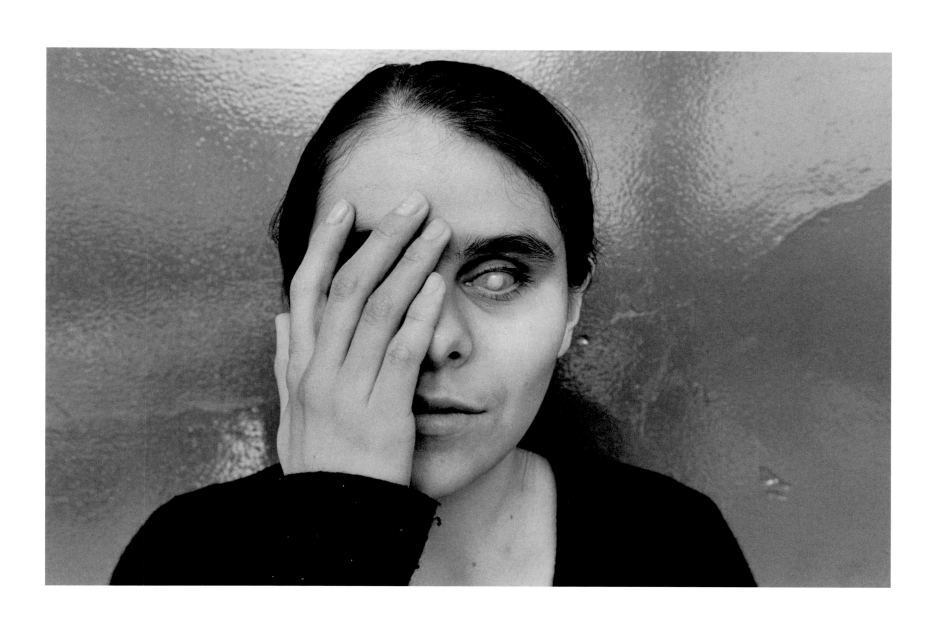

Plate 22 2000

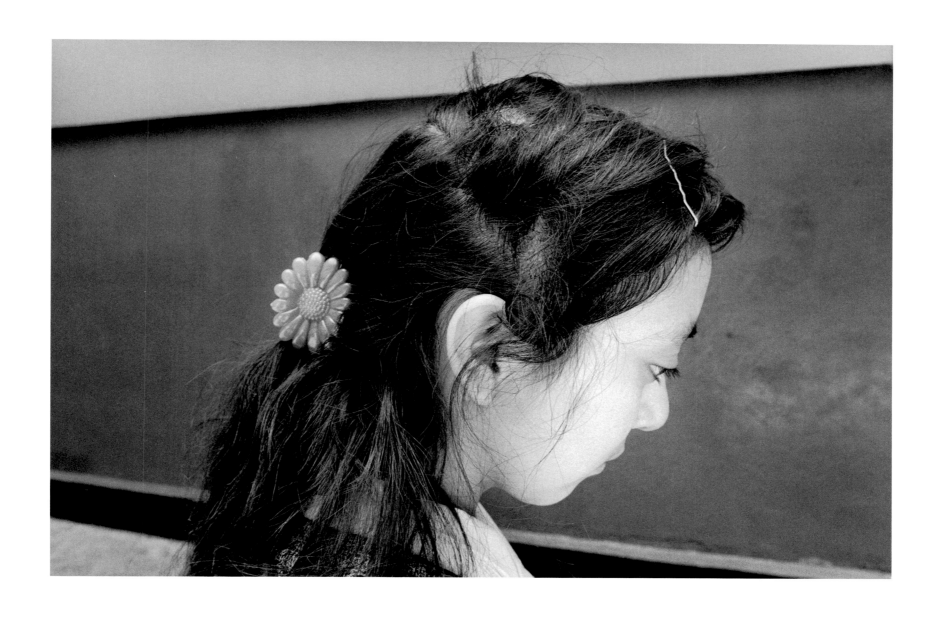

Plate 23 1999

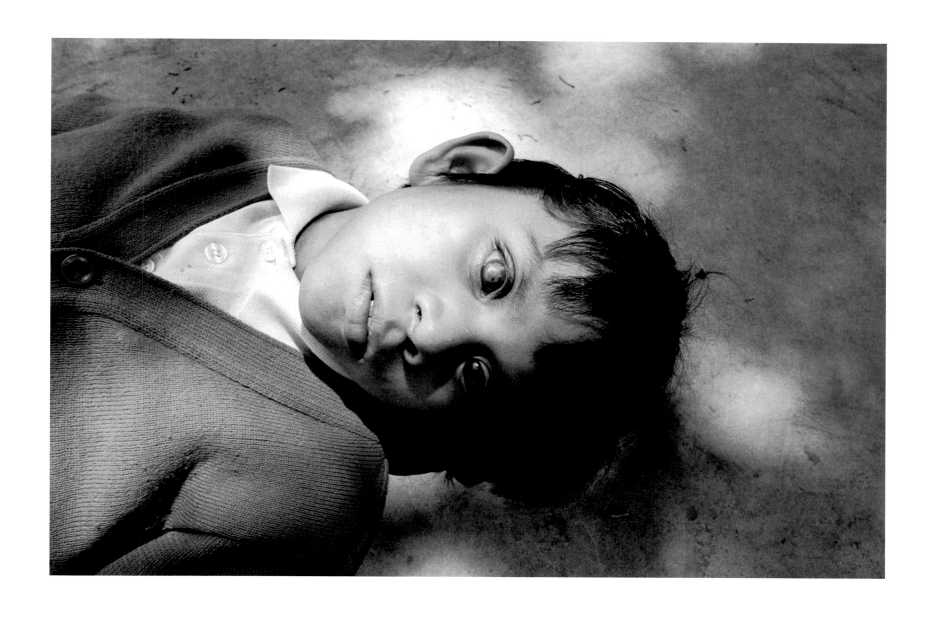

Plate 24 1999

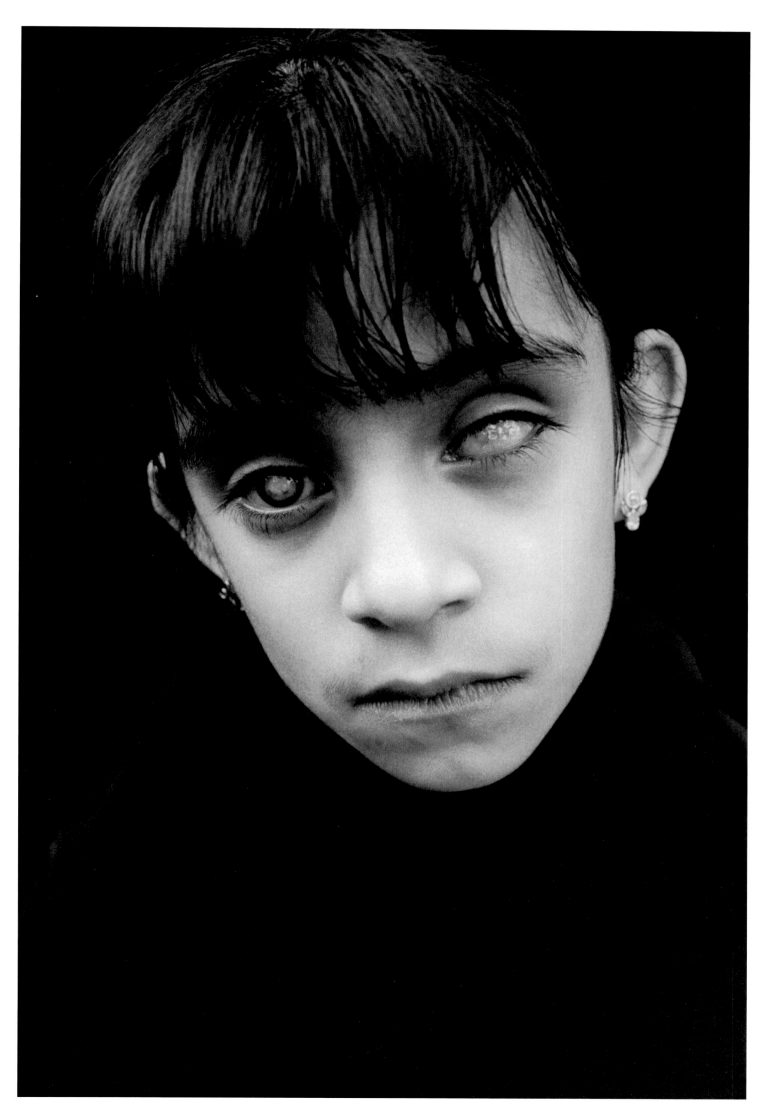

Plate 25 2005

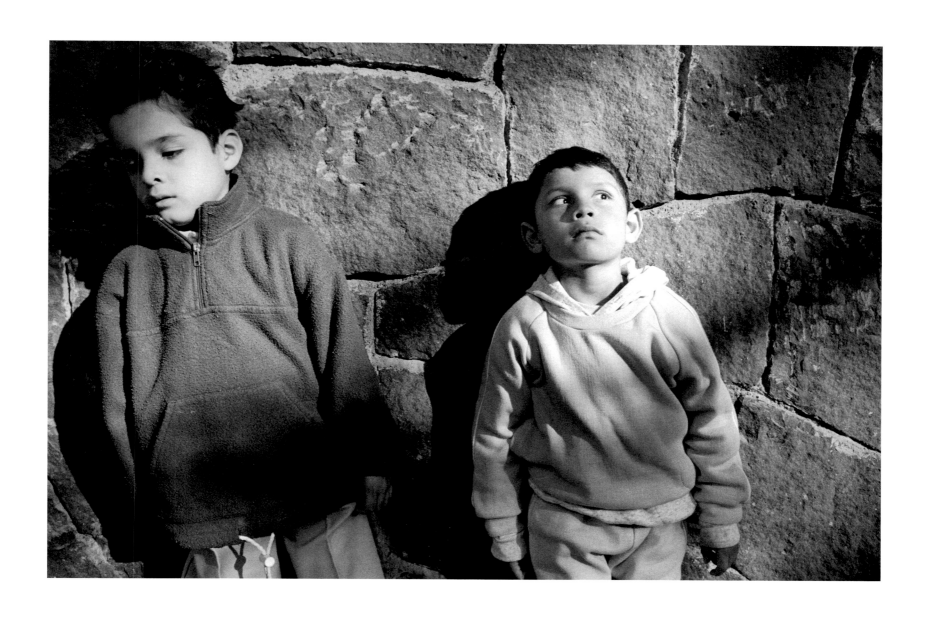

Plate 26 1998

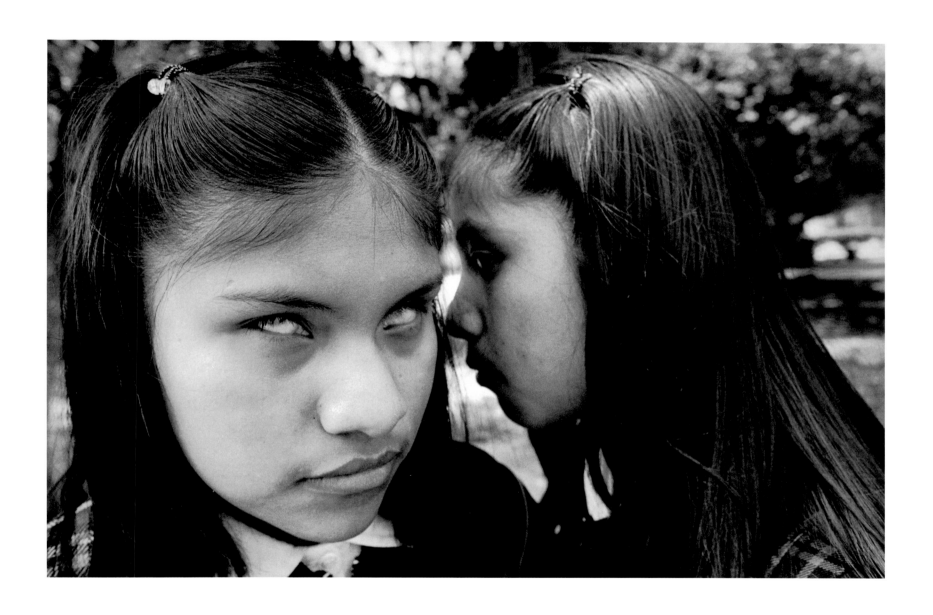

Plate 27 1999

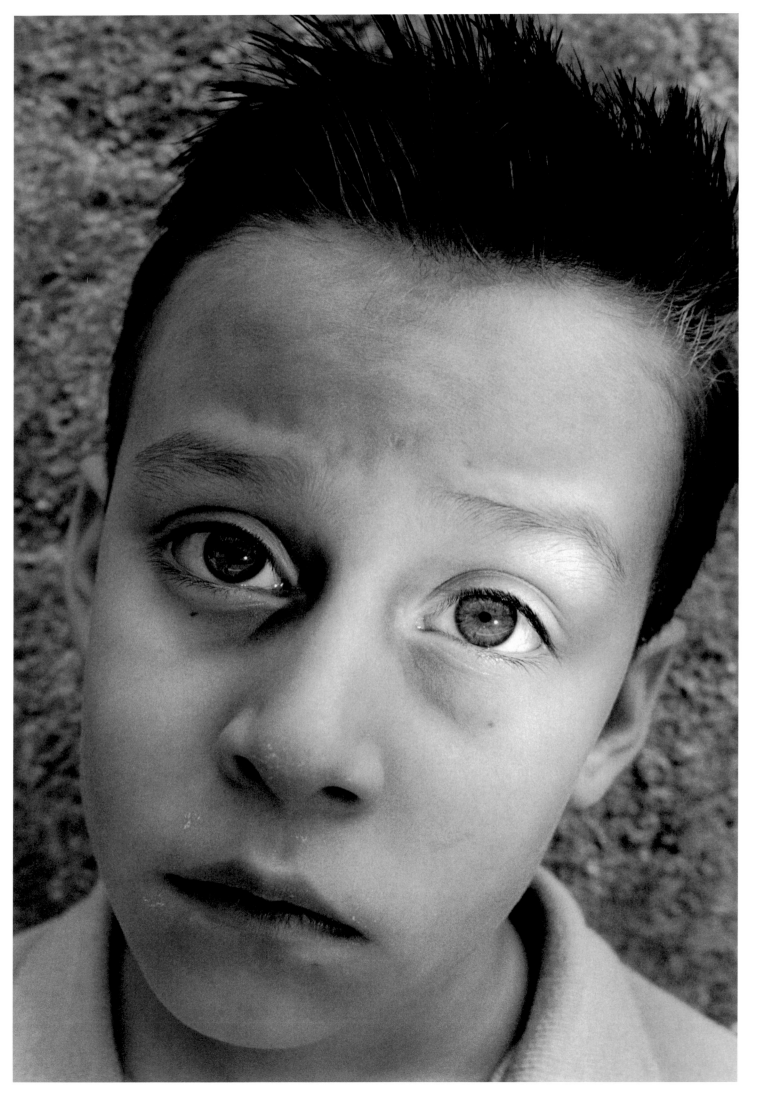

Plate 28 2005

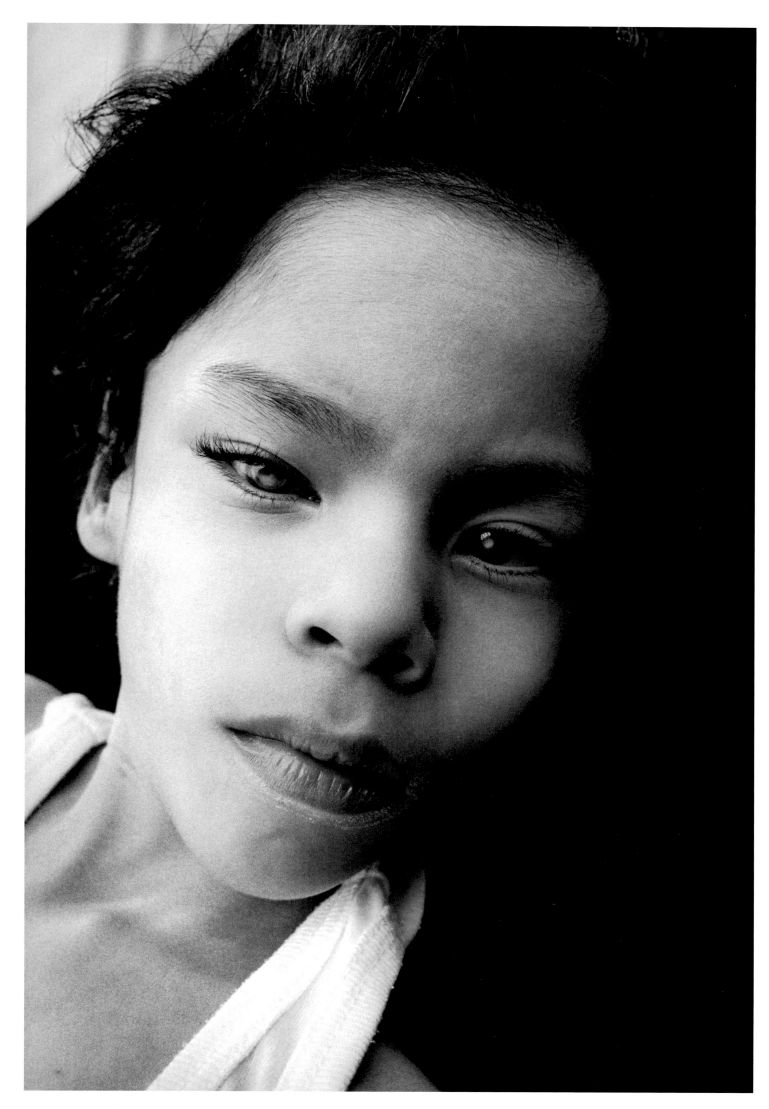

Plate 29 2003

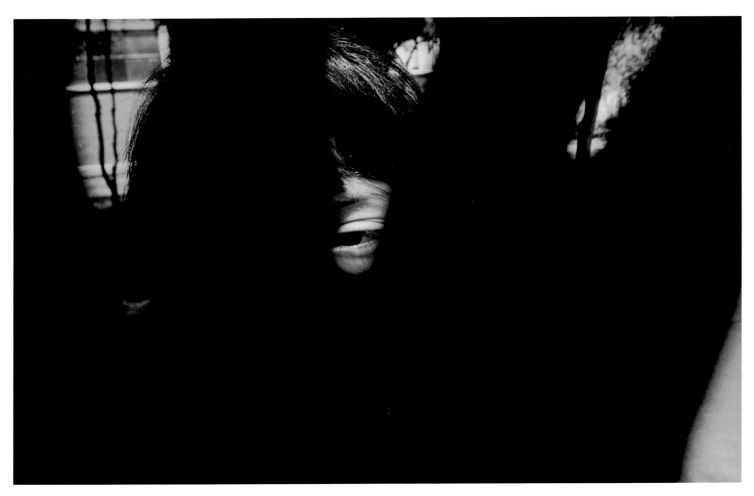

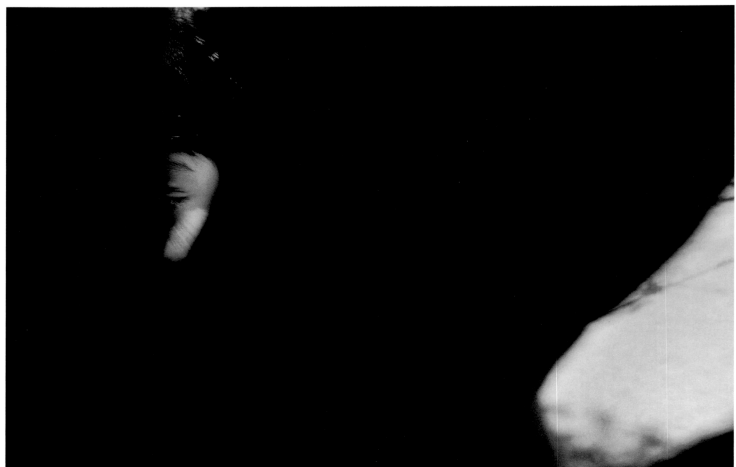

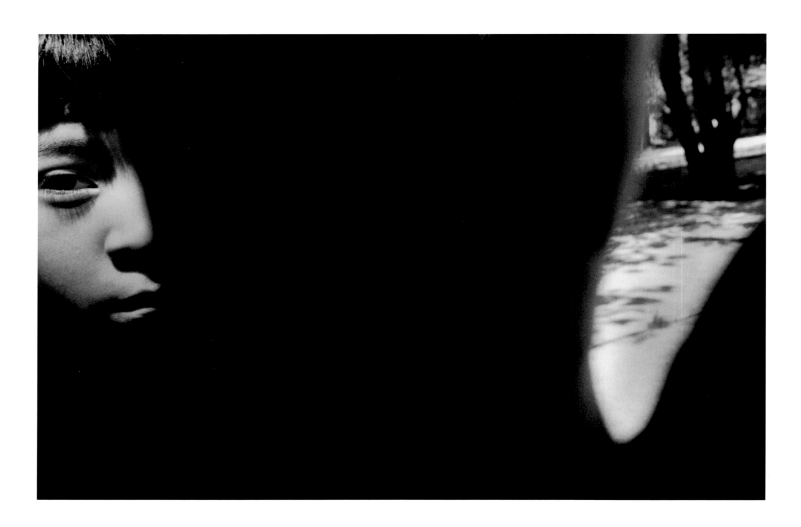

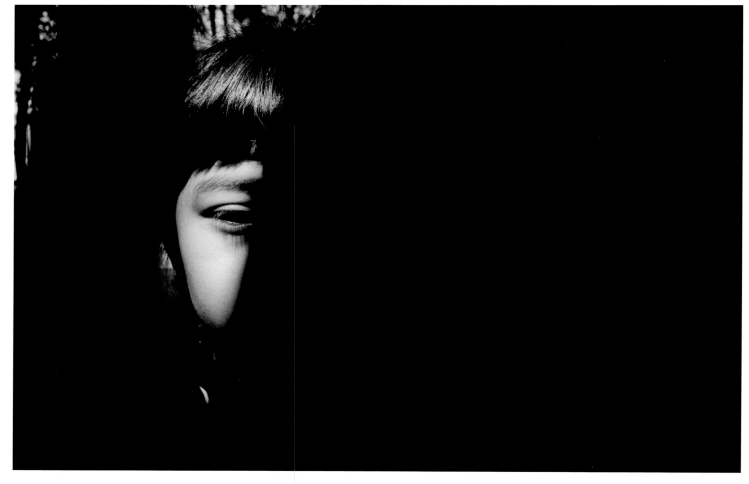

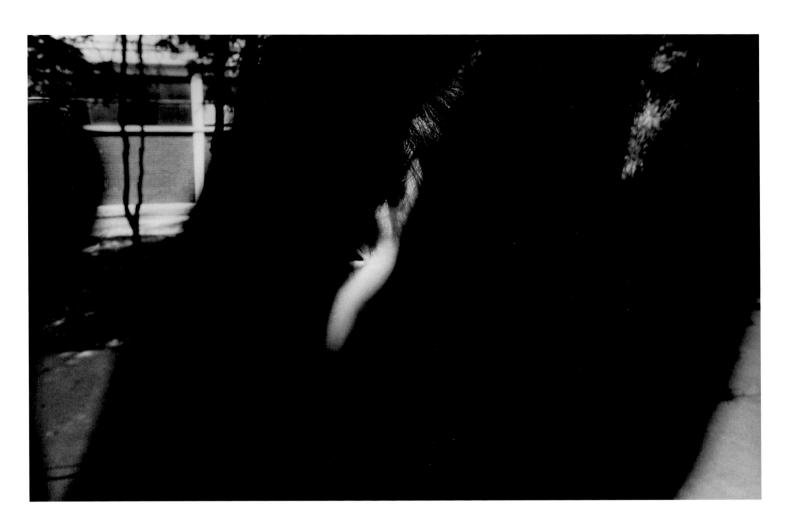

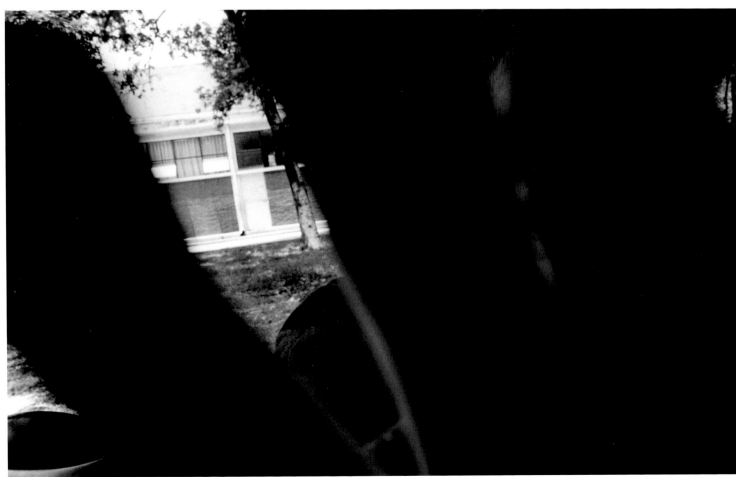

Plate 30 1999 Plate 32 1999 Plate 34 1999
Plate 31 1999 Plate 33 1999 Plate 35 1999

Plate 30 1999 Plate 32 1999 Plate 34 1999
Plate 31 1999 Plate 33 1999 Plate 35 1999

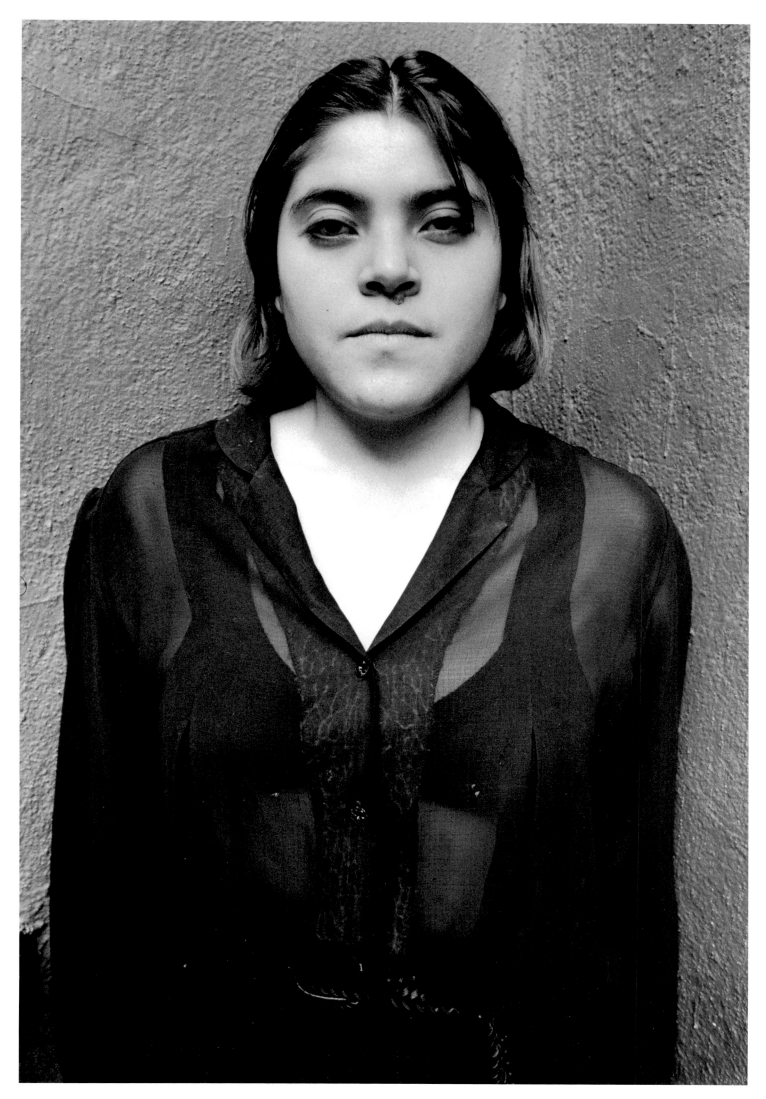

Plate 36 1998

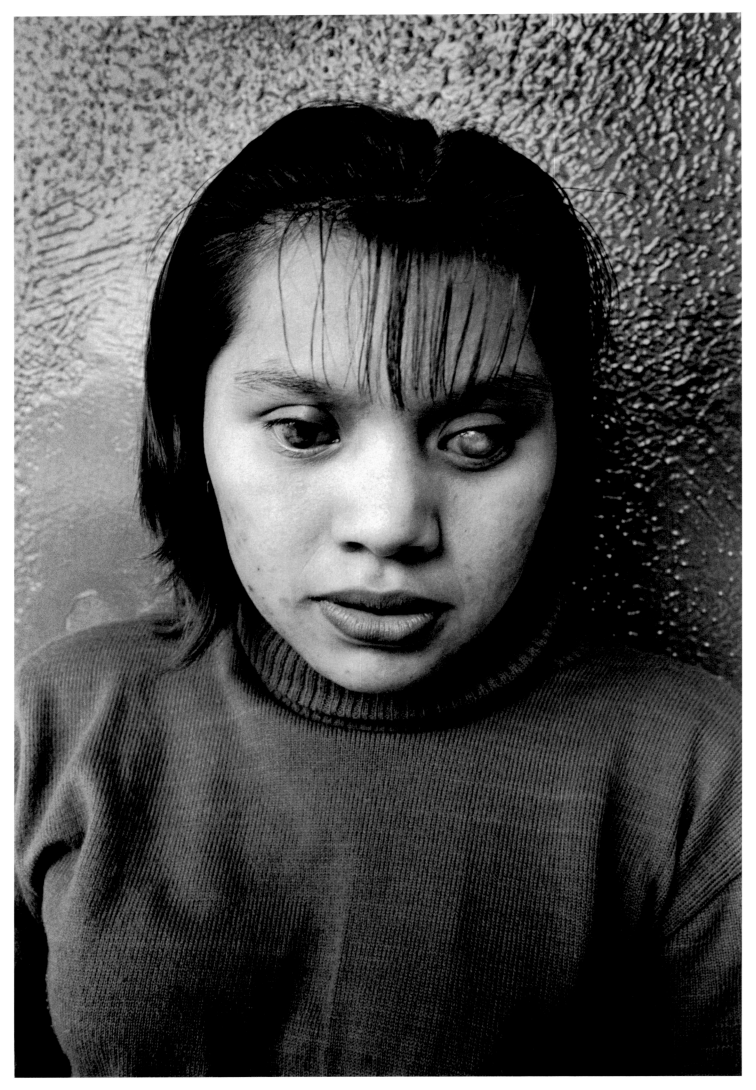

Plate 37 1999

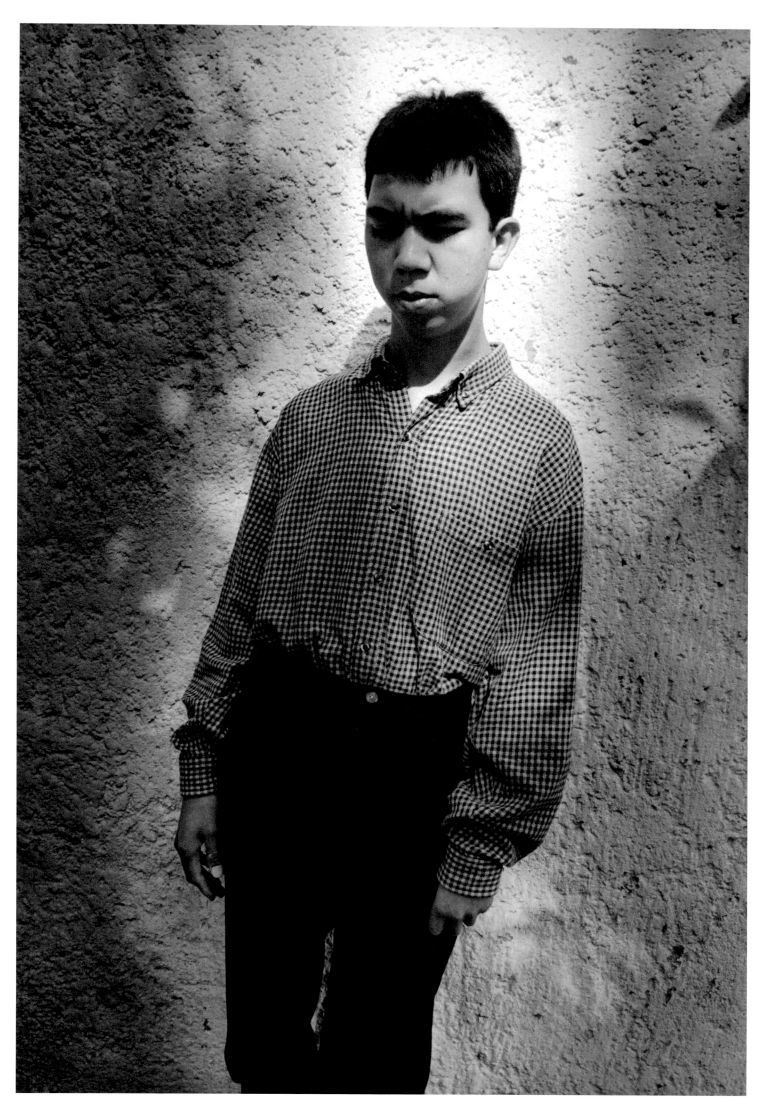

Plate 38 1998

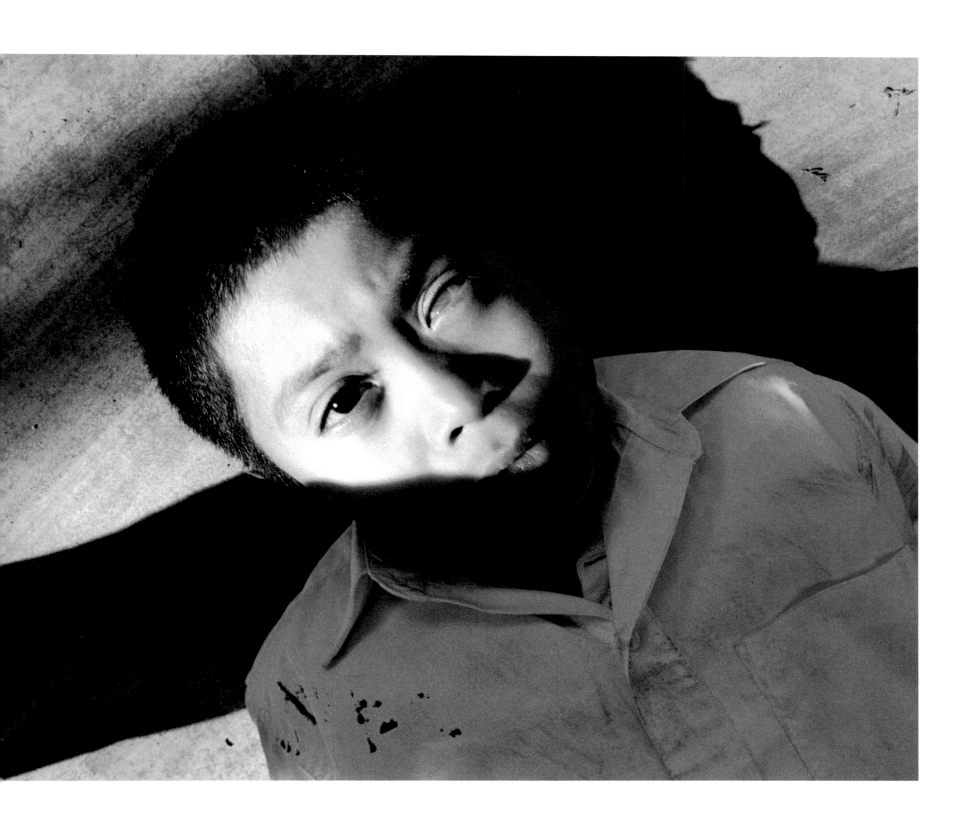

Plate 39 2000

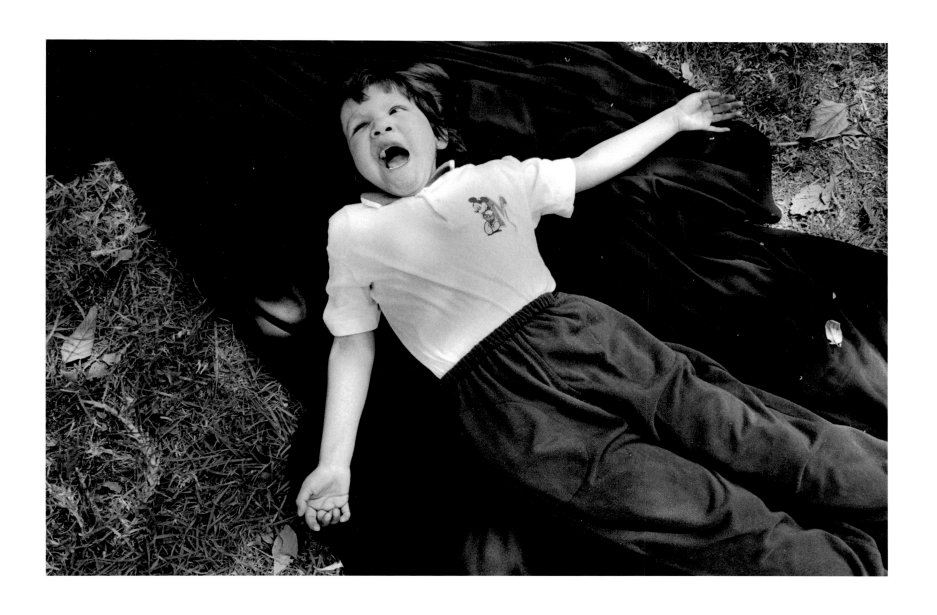

Plate 40 1999

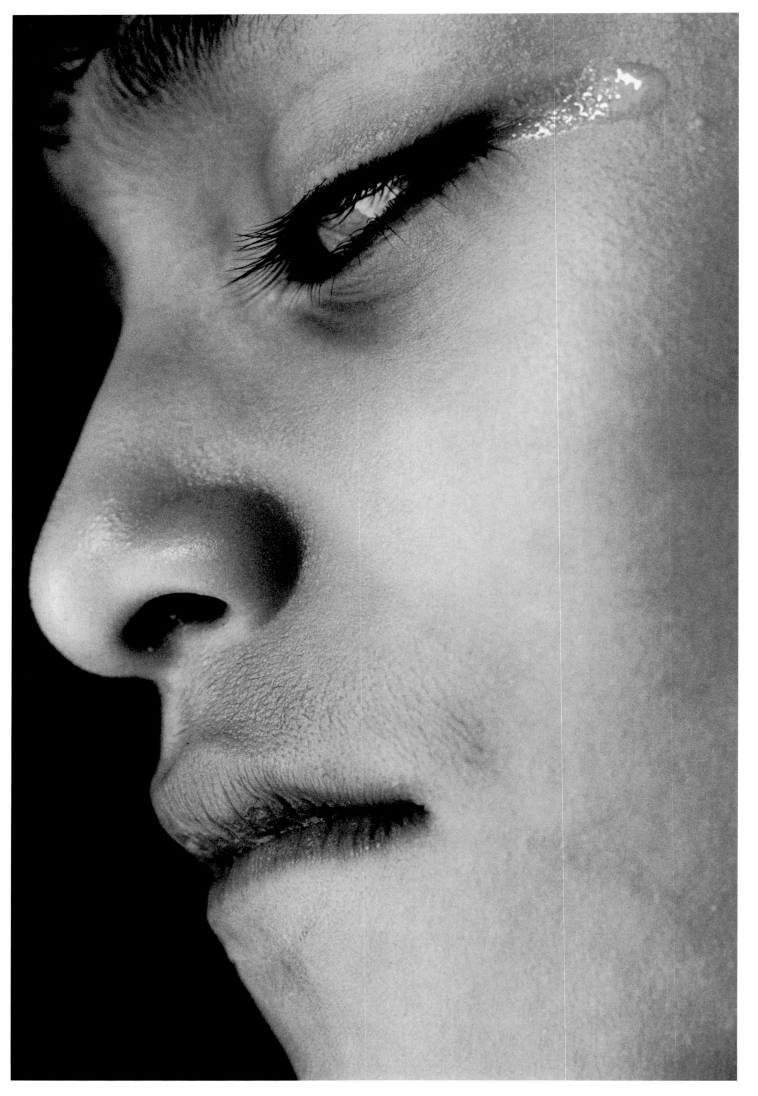

Plate 41 2005

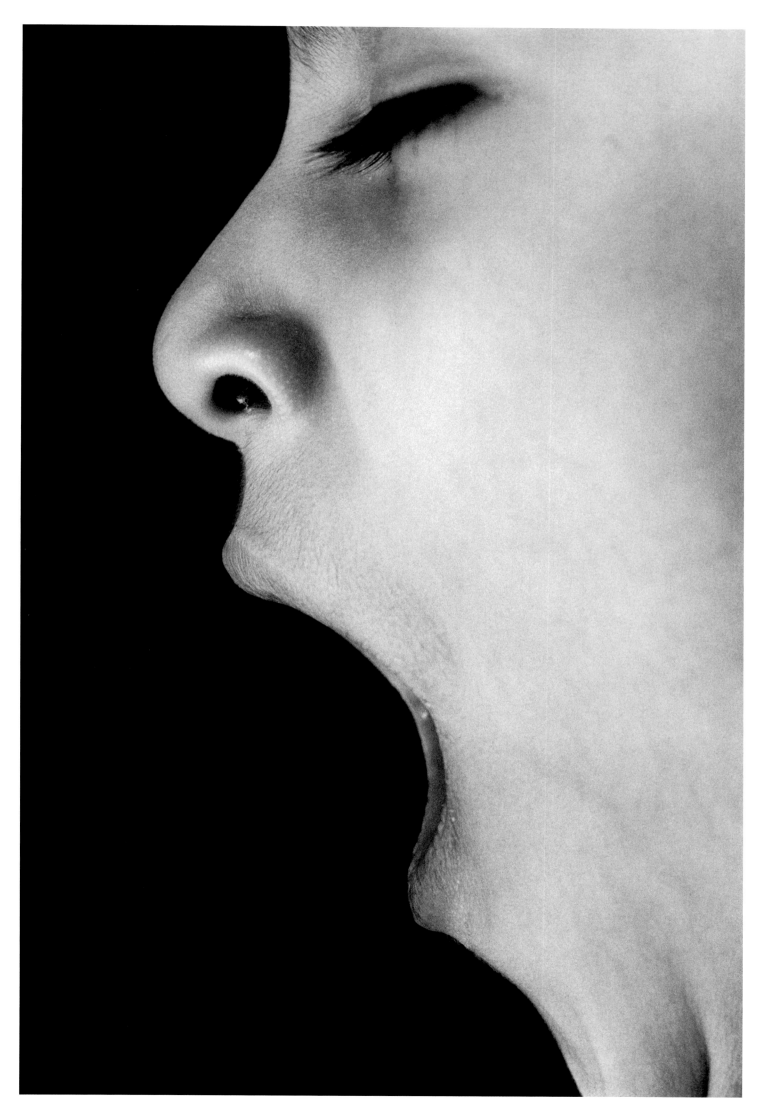

Plate 42 2005

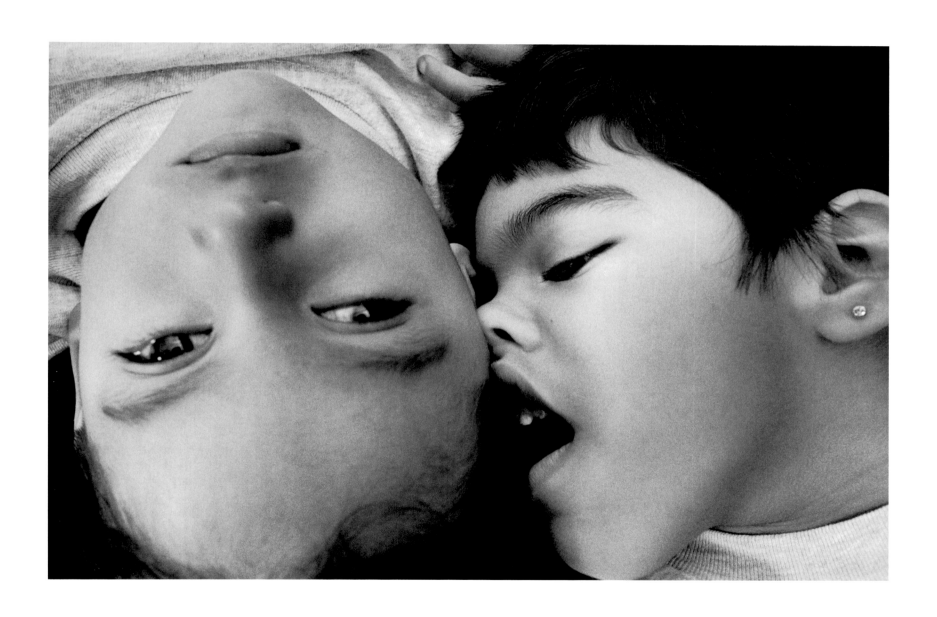

Plate 43 2003

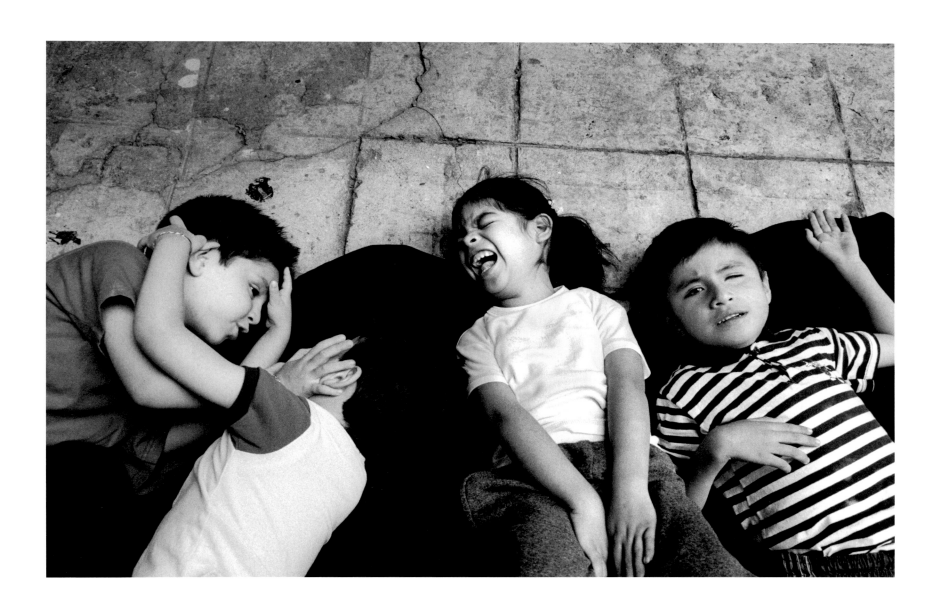

Plate 44 2001

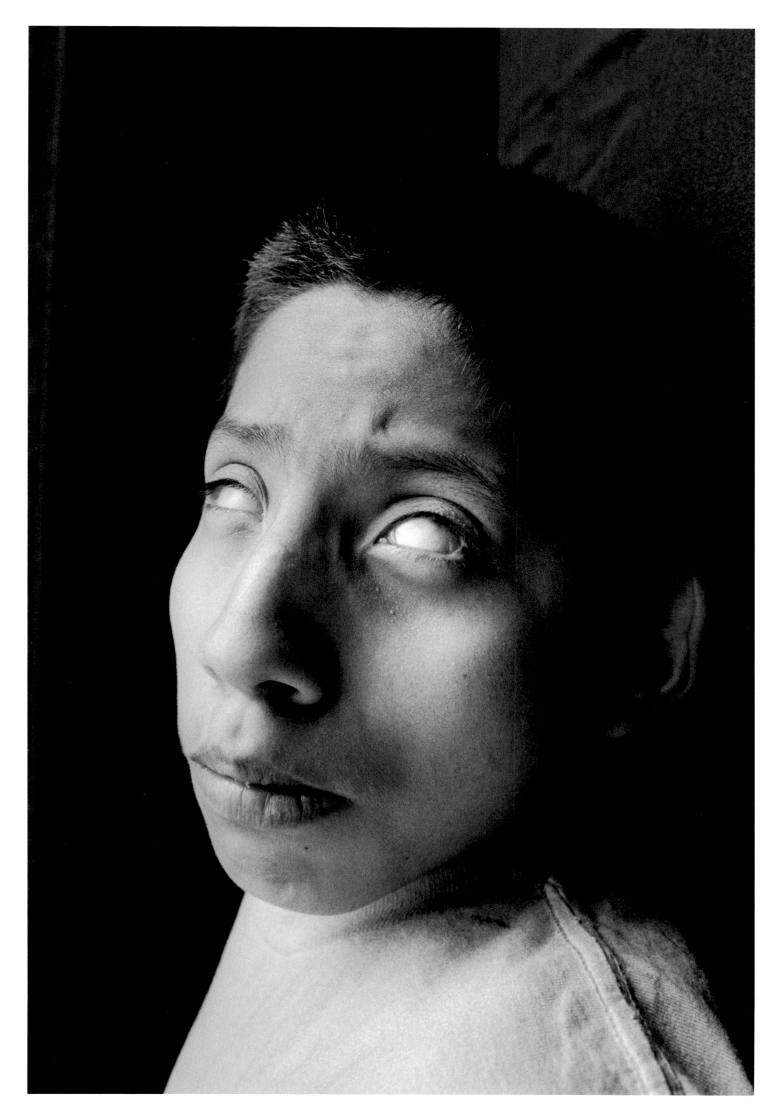

Plate 45 2003

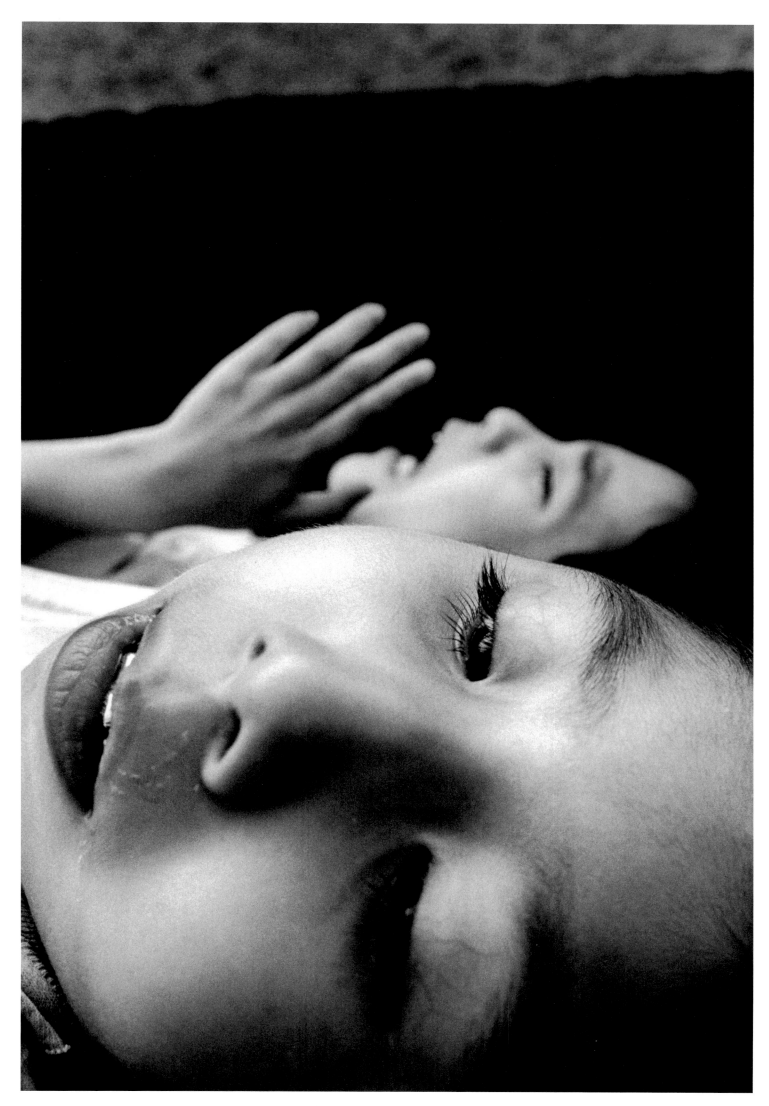

Plate 46 2003

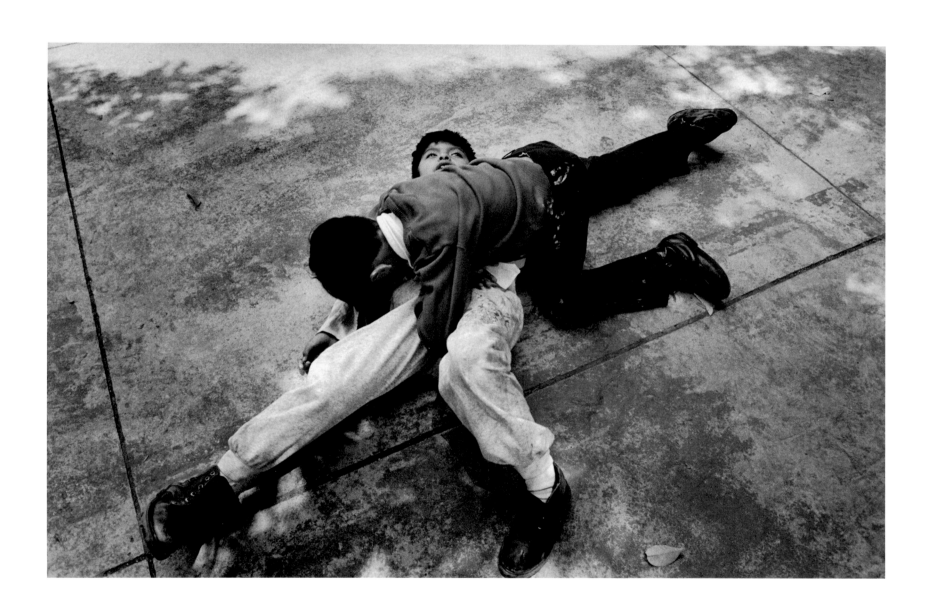

Plate 47 1999

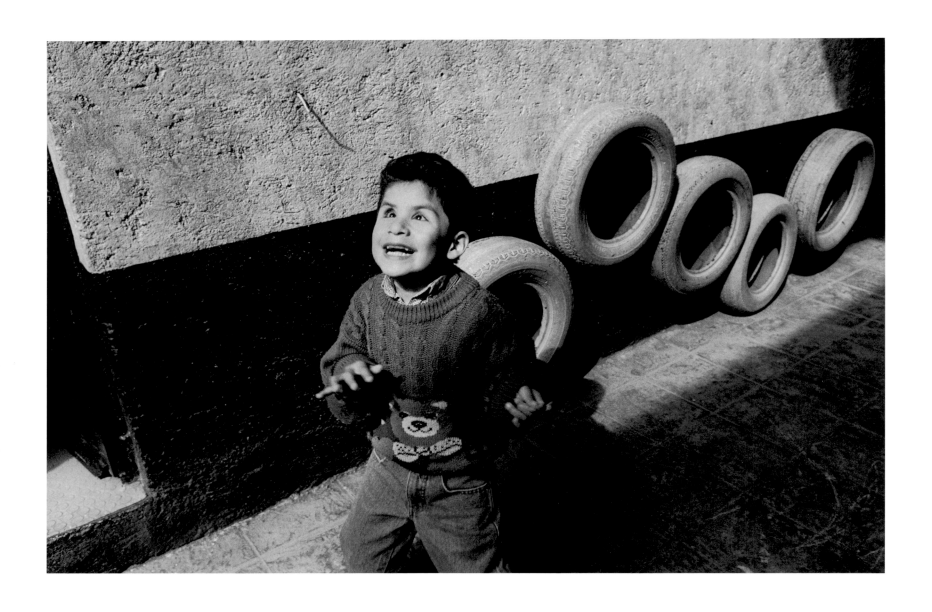

Plate 48 2001

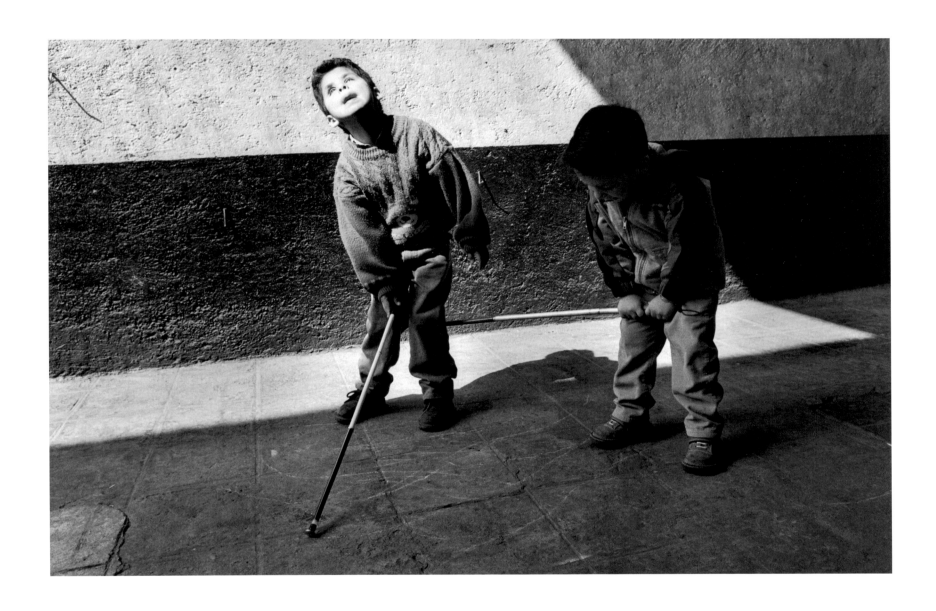

Plate 49 2001

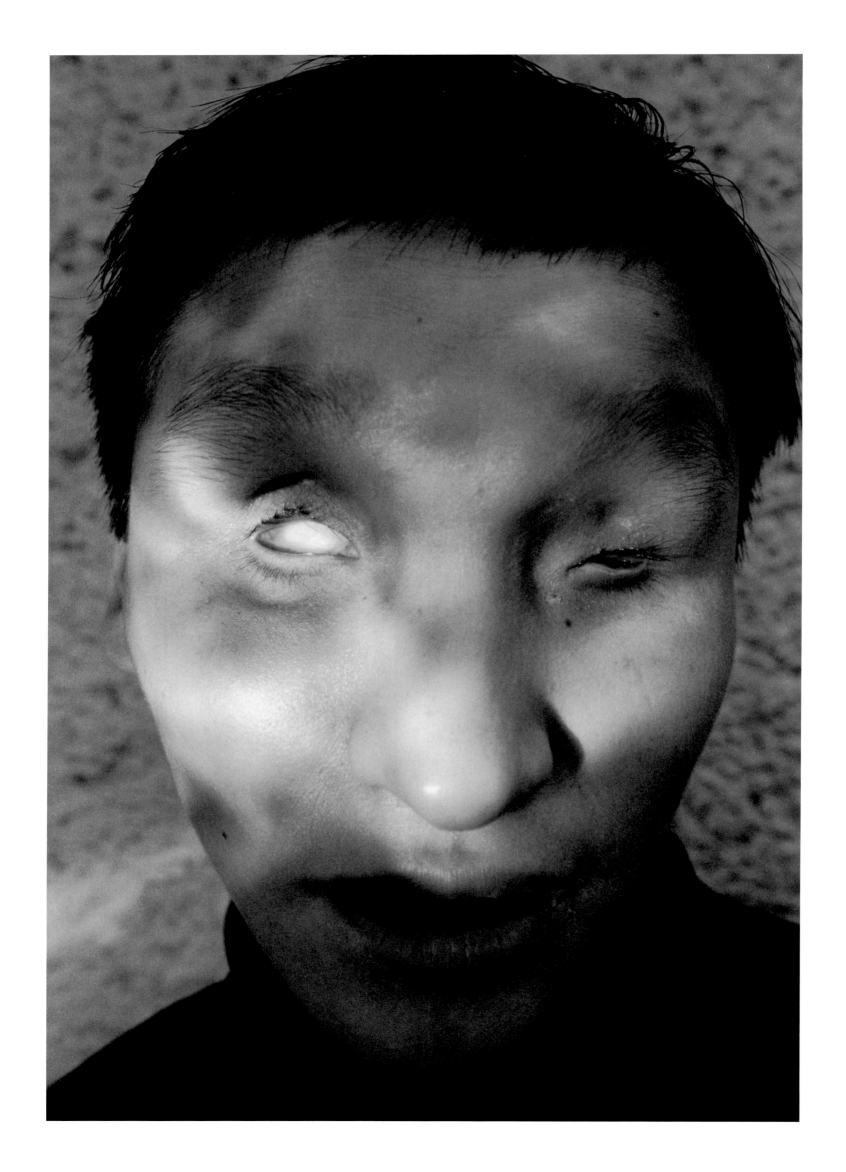

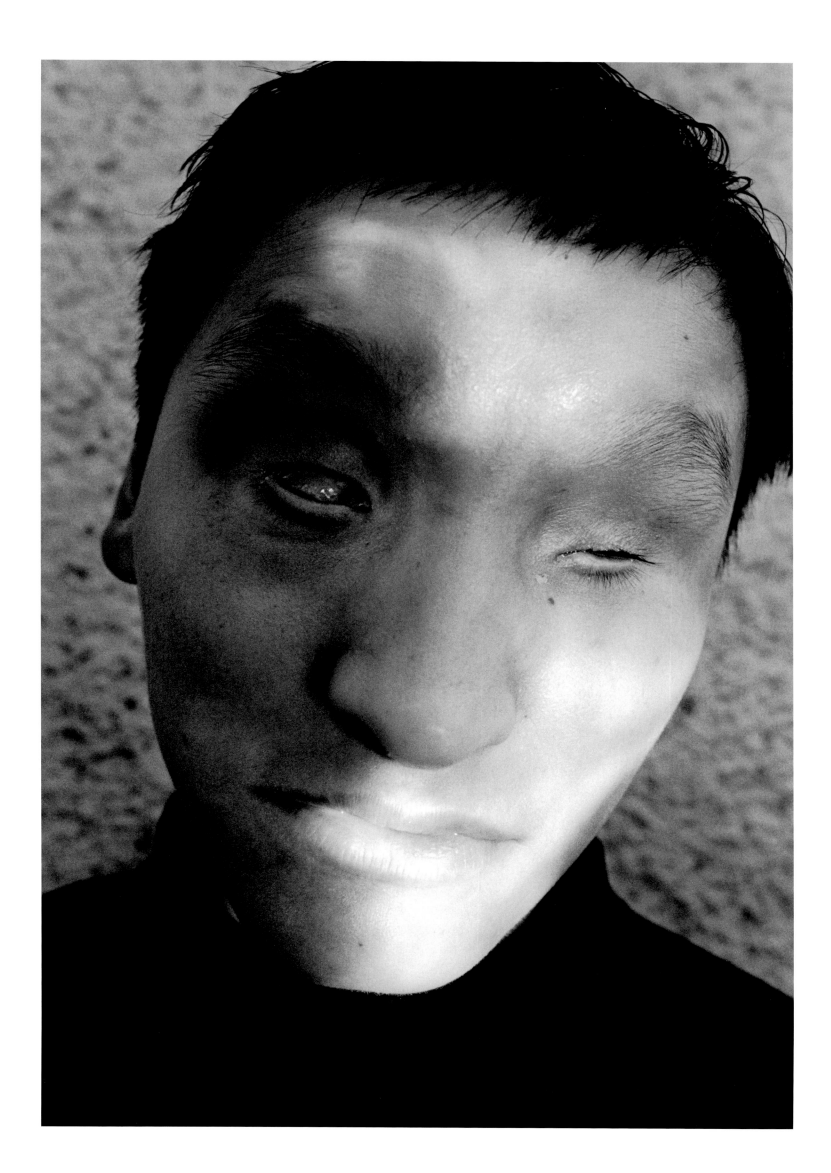

Plate 50 2005
Plate 51 2005

Plate 52 2005
Plate 53 2005

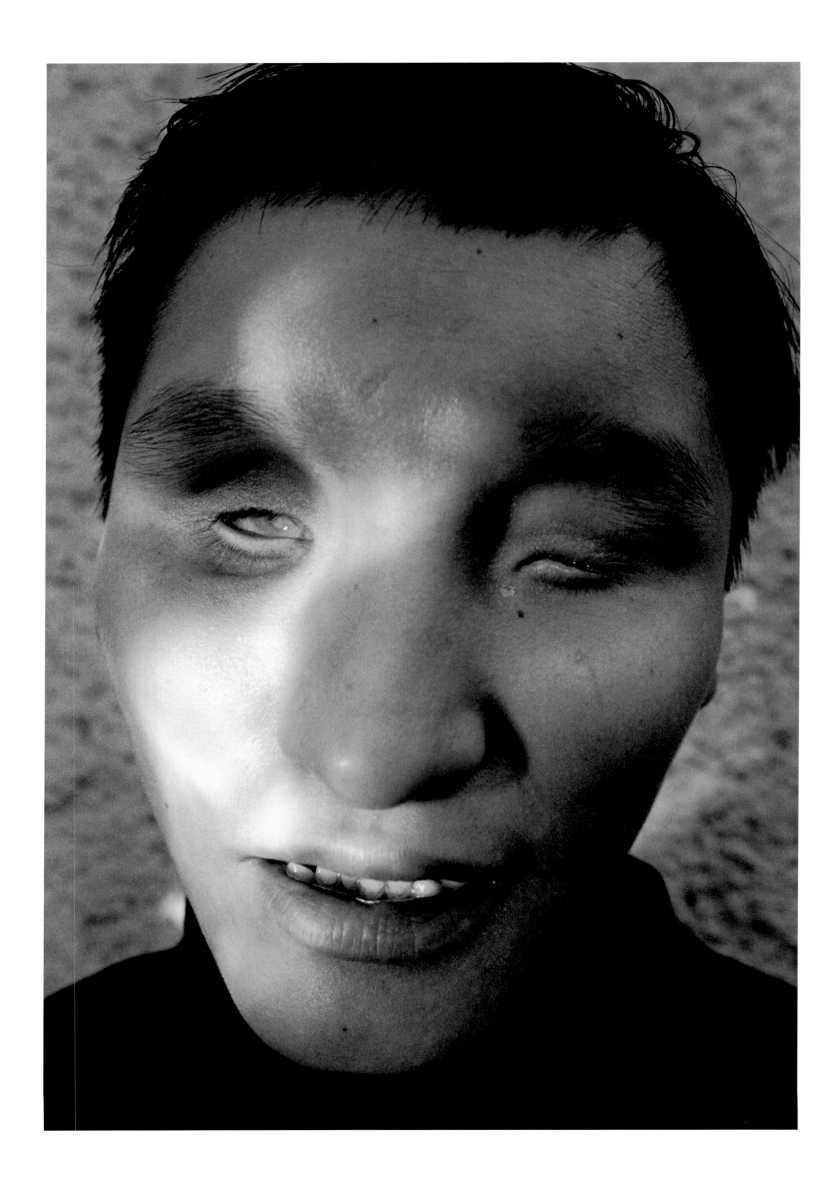

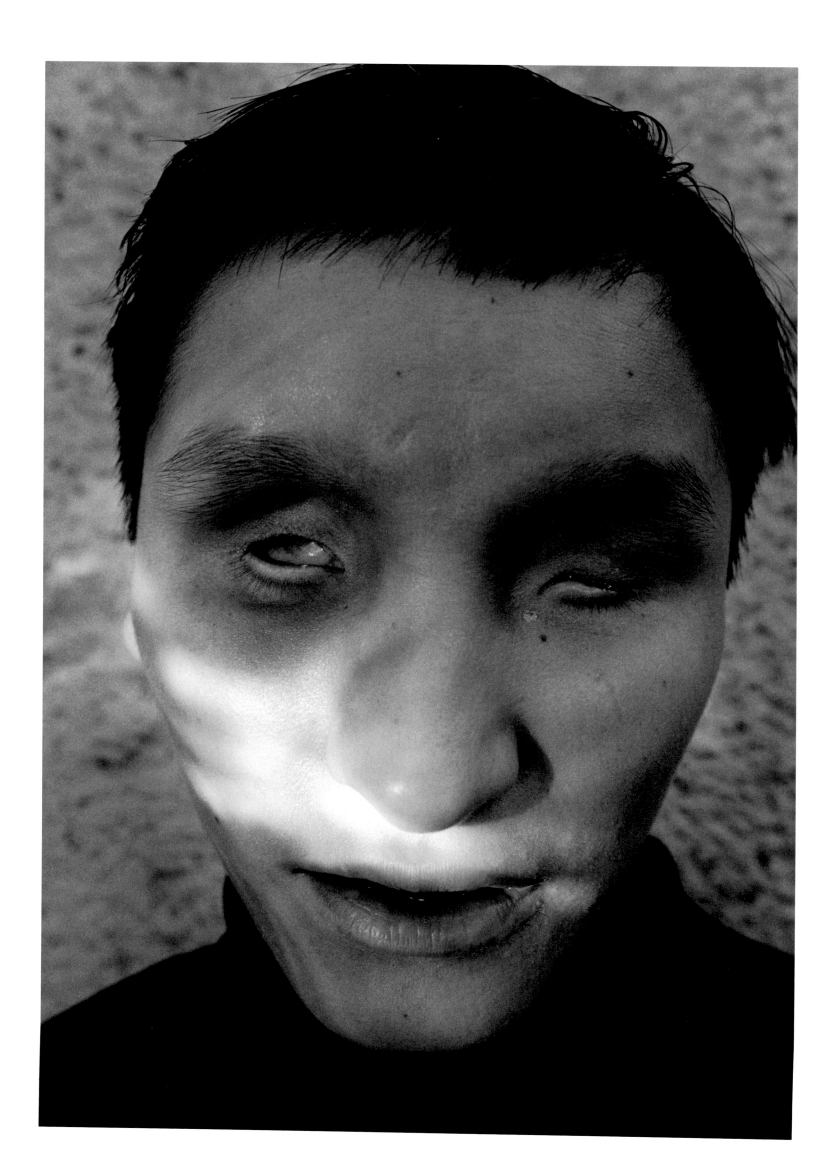

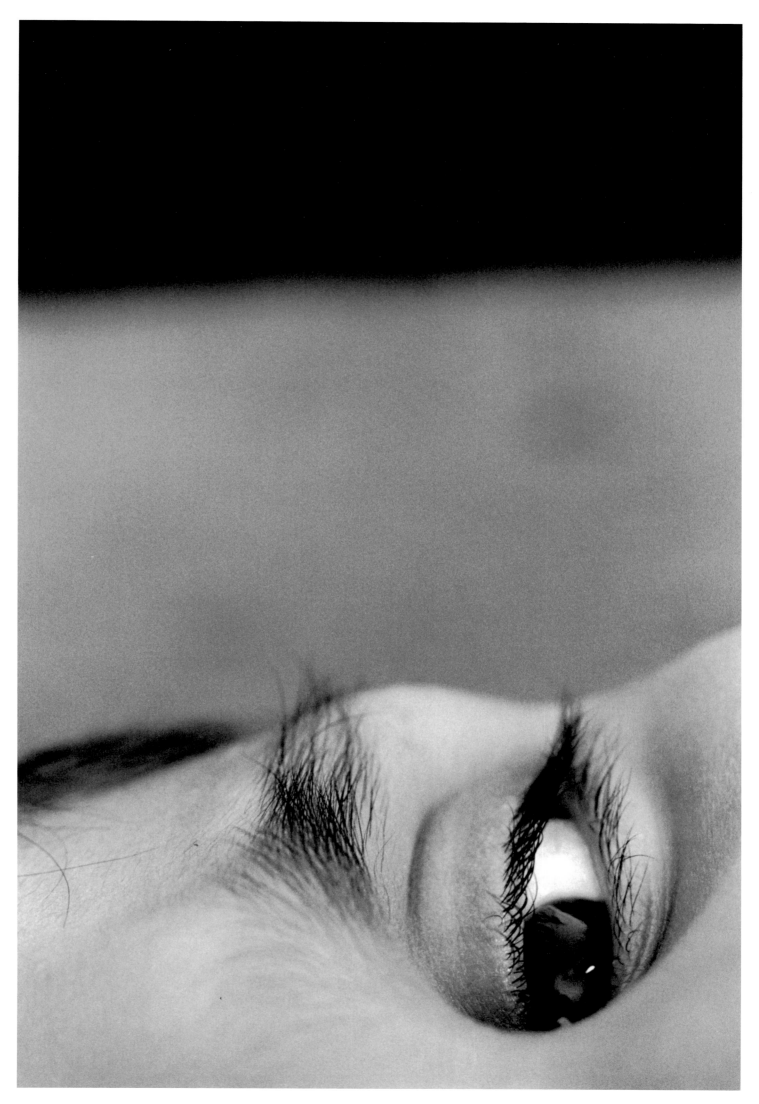

Plate 54 2005

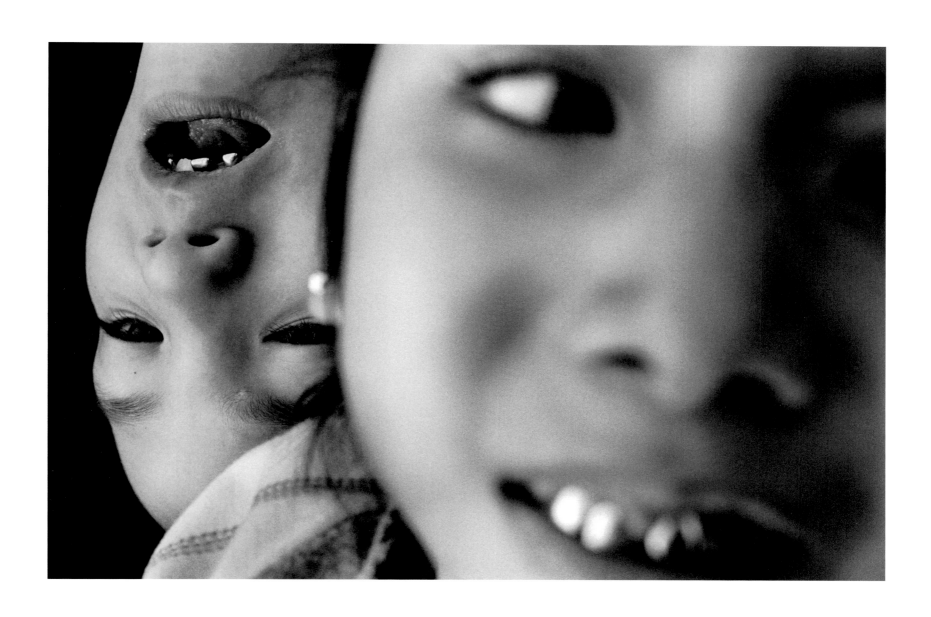

Plate 55 2003

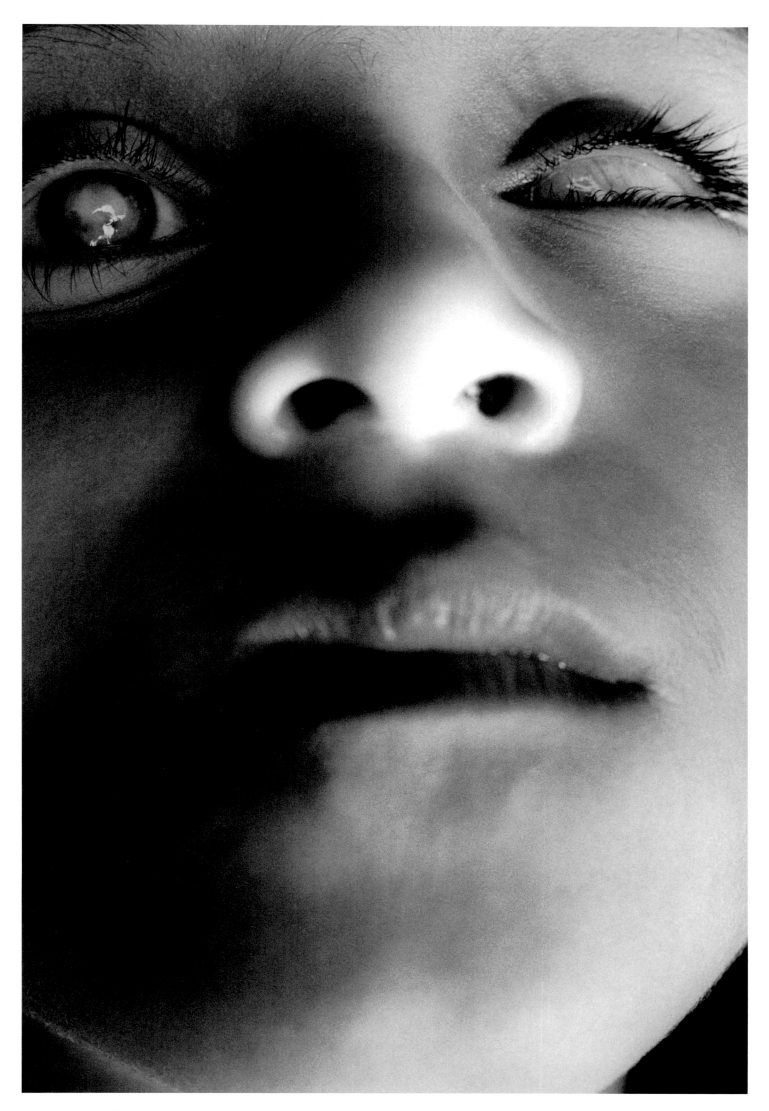

Plate 56 2005

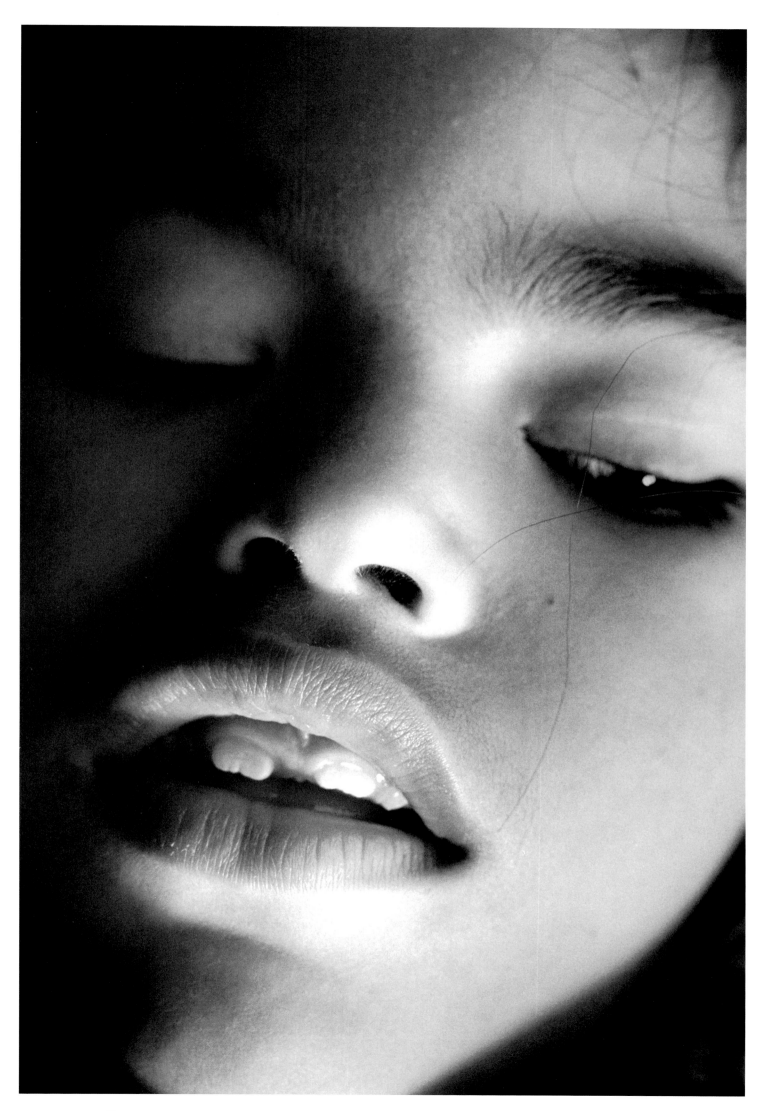

Plate 57 2005

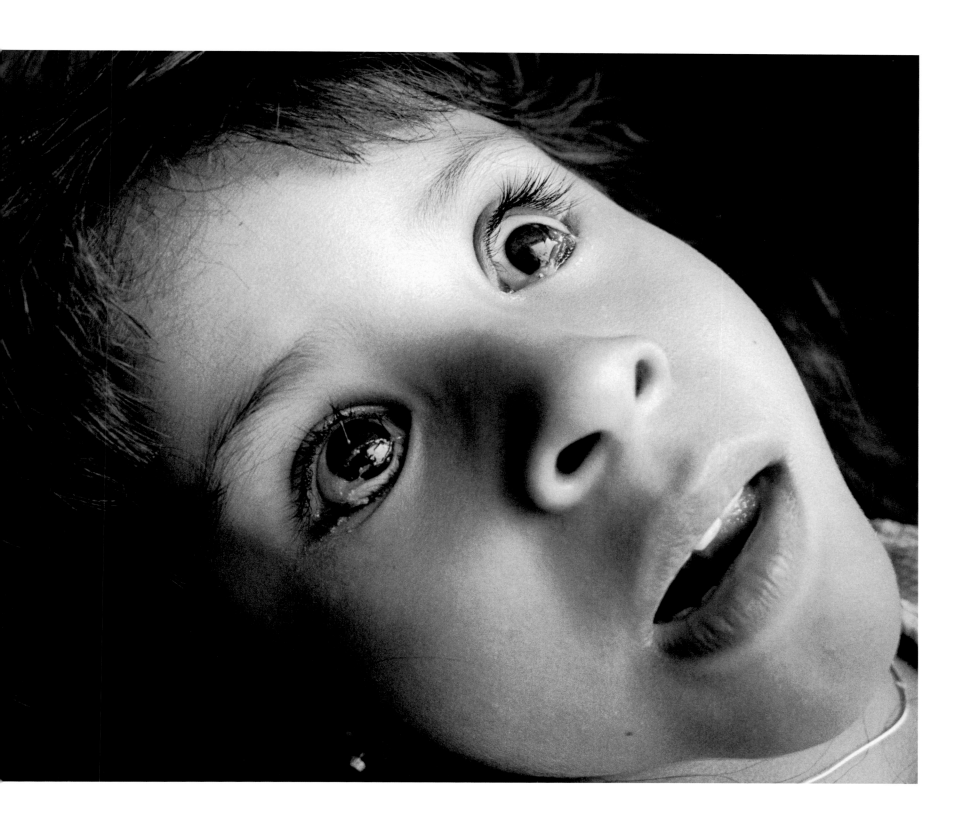

Plate 58 2003

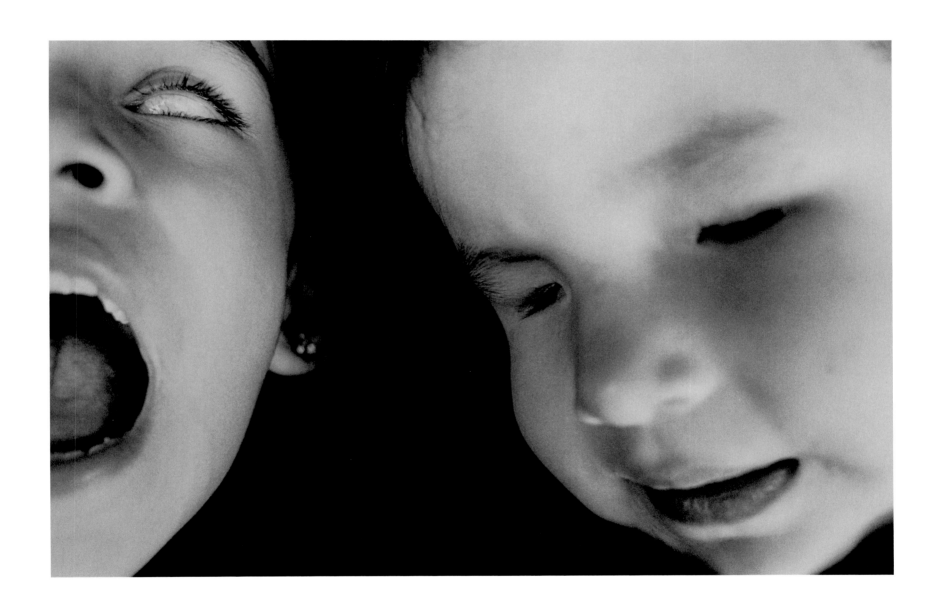

Plate 59 2005

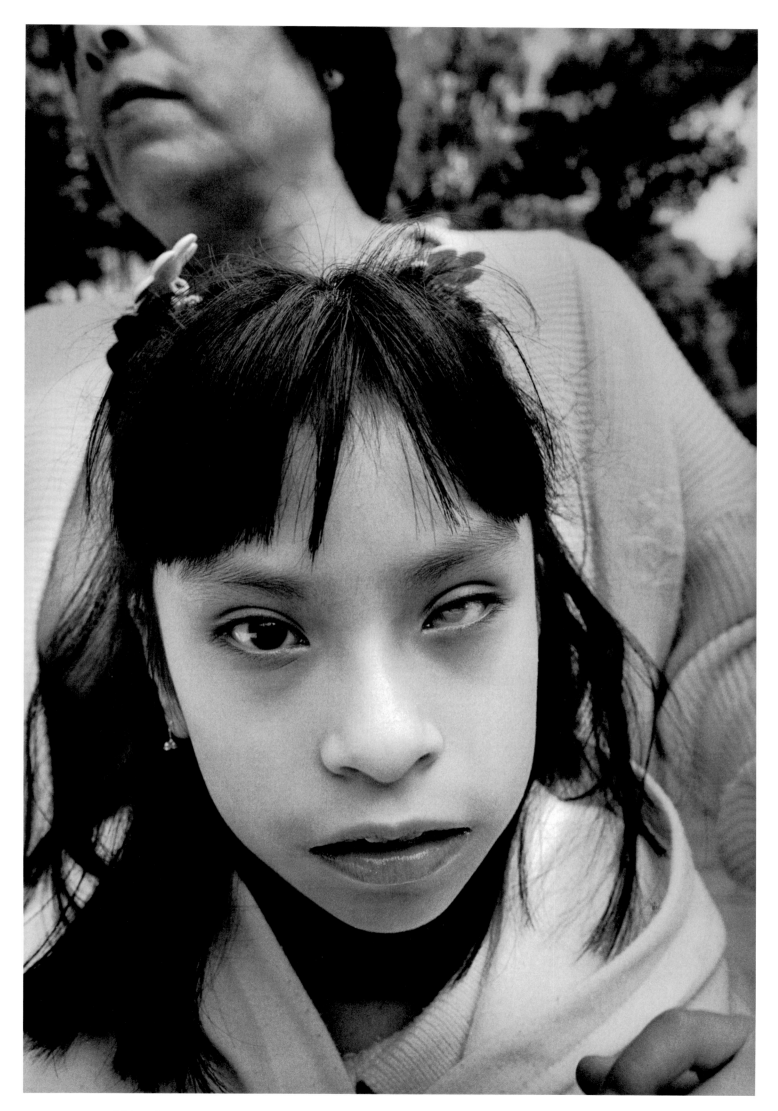

Plate 60 2000

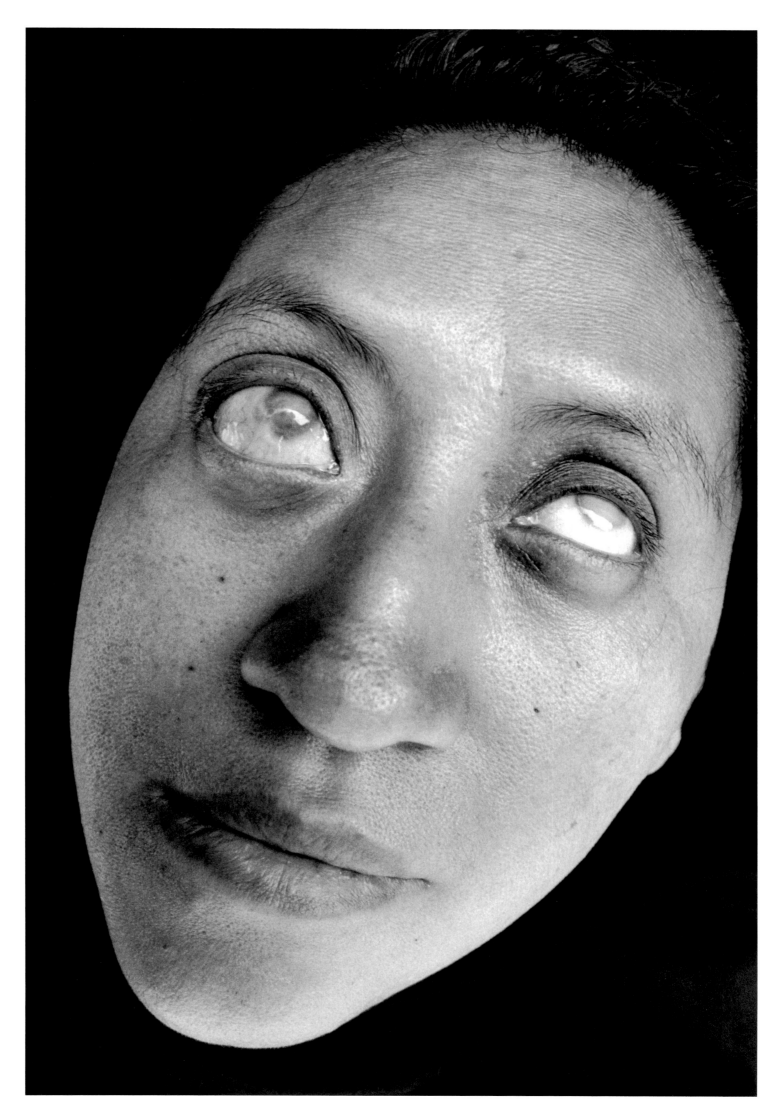

Plate 61 2003

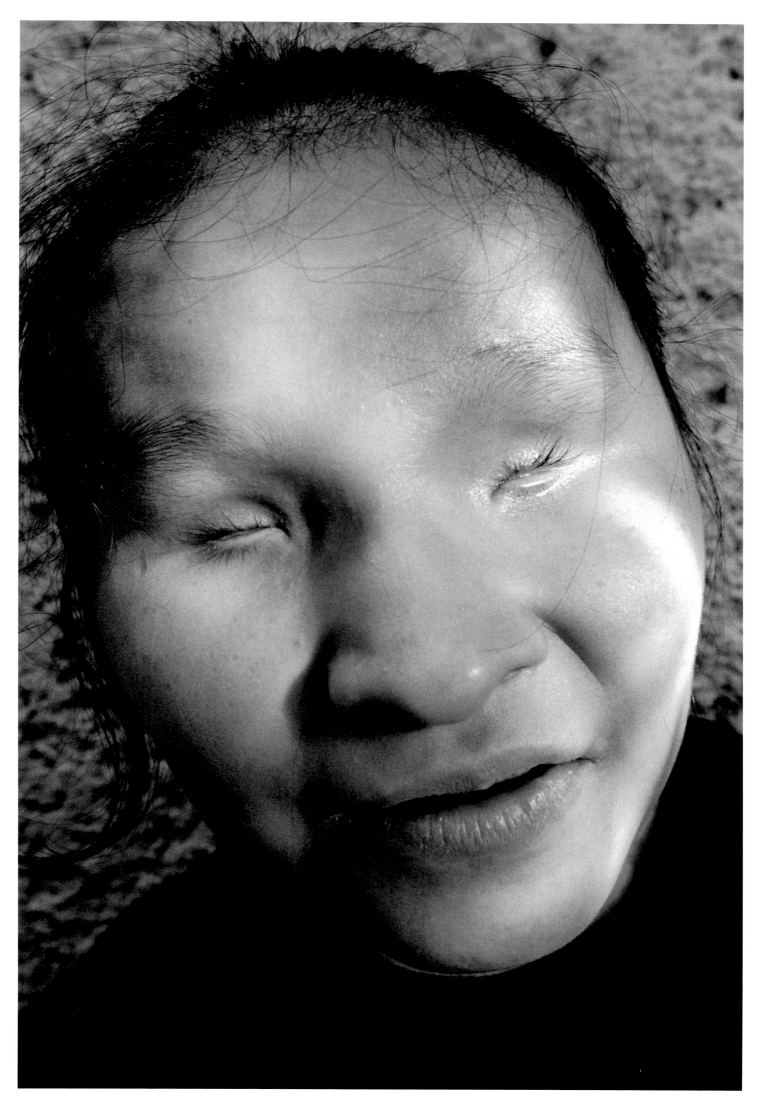

Plate 62 2005

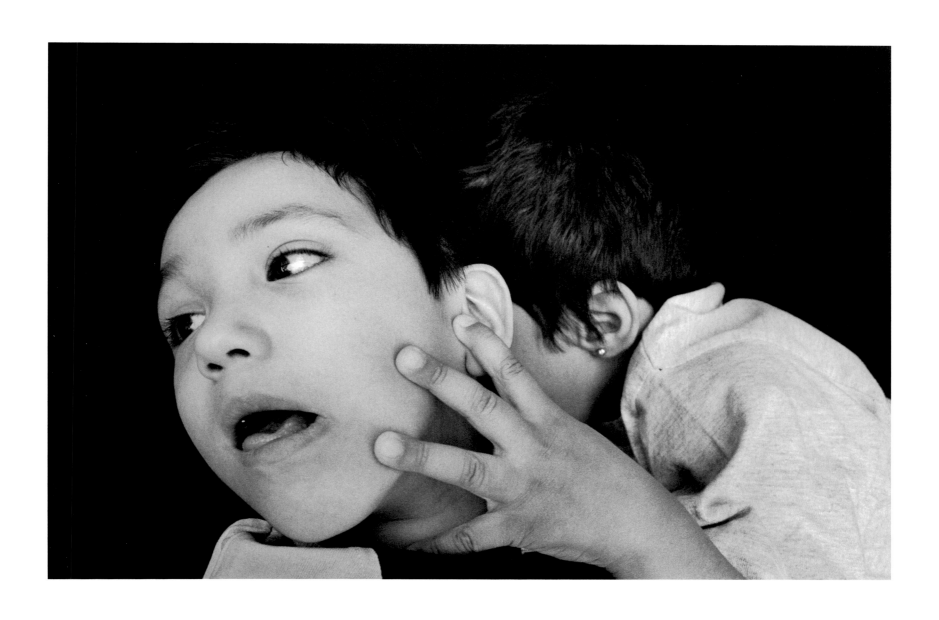

Plate 63 2003

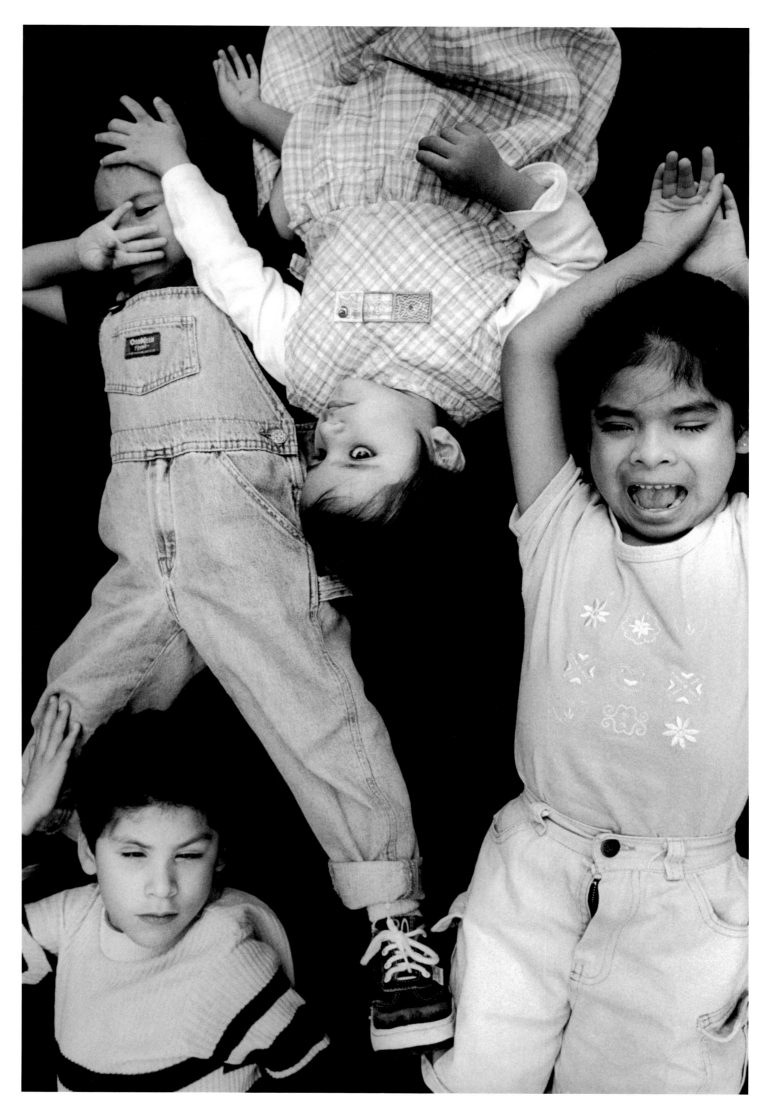

Plate 64 2002

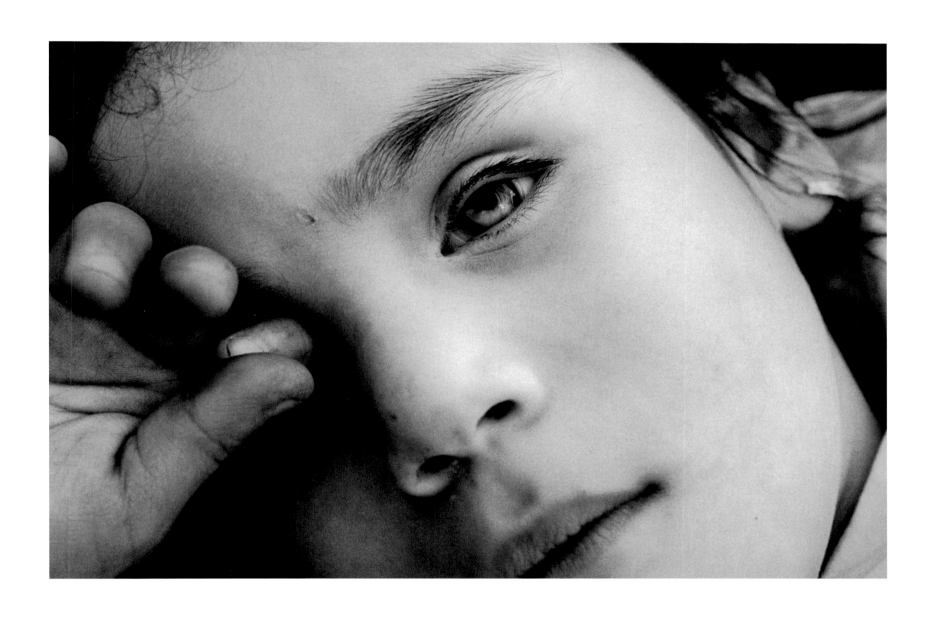

Plate 65 2002

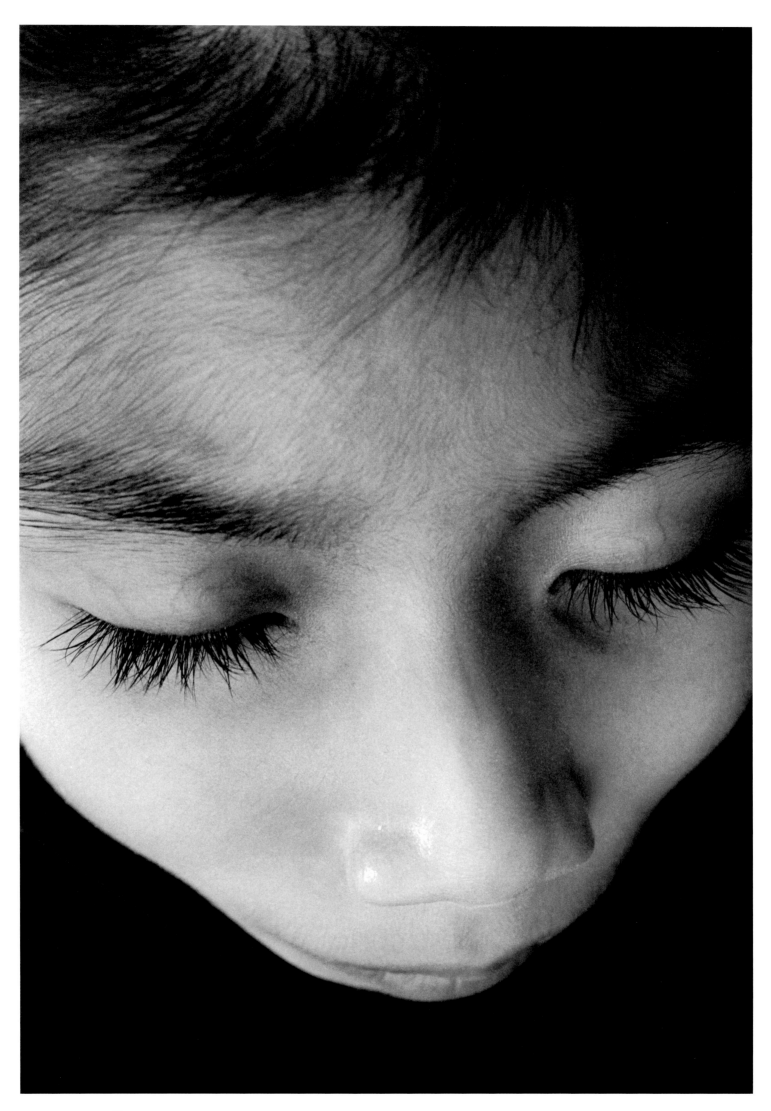

Plate 66 2005

Acknowledgments

In 1991, at a party in Chicago, I asked the eminent Mexican photographer Pablo Ortiz Monasterio whether he knew of any schools for the blind in his country where I might be allowed to photograph. He subsequently sent me information about a school in the Coyoacán district of Mexico City. I had, at one point, tried to photograph blind children in Naples, Italy, but, perhaps because I had worked there for so many years, the pictures seemed too closely tied to my street work. I needed to find a way to isolate the idea, to define the pictures in a new way. In December of 1998, carrying a letter of introduction that had been translated for me into Spanish, I arrived in Mexico City hoping to begin work on a series of photographs of blind children. During the next seven years, I made nine trips to the city to photograph in four schools for the blind.

Over the course of those seven years, many people, both in Mexico and the United States, went out of their way to help me realize this work. First and foremost, I thank the children, faculty, administrators, and parents for allowing me access to their daily lives at the schools. Without the parents' unqualified support, and the children's enthusiastic participation in the process of being photographed, these pictures would not exist. In particular, Marta E. Ramirez, Director, and Martha Levinson, Secretary, of *CHIPI* school (Centro de Habilitación y Integración Para Invidentes, I. A. P.), and Ruth Franco Garcia, Director of *CRECIDEVI* school (Centro de Rehabilitación Para Ciegos y Débiles Visuales Fundación Conde de Valenciana), were instrumental in helping to ensure that this project was fulfilled. Their genuine interest in this work, and their kindness, led to friendships that I will always treasure. In addition, I thank Dr. Oscar Ceballos Cortés, Director of Instituto Nacional de Rehabilitación de Niños Ciegos y Débiles Visuales, and Martha Valdés, Director of Escuela Nacional de Invidentes y Para Ciegos, both of whom, after reading my letter, helped me gain permission to photograph in the schools. I am, of course, indebted to Pablo Ortiz Monasterio, whose assistance allowed me to begin this series of pictures.

It has been a pleasure to work with the Studio Blue team of Kathy Fredrickson, Cheryl Towler Weese, Claire Williams, Rob Mach, and Siobhan Drummond, and I thank them for their elegant design. In particular, I am deeply grateful to Kathy and Claire for their energy, dedication, and imagination during this long collaboration. My whole-hearted gratitude and appreciation goes to Terry Ann R. Neff of t. a. neff associates, inc., whose advice, spirit, and editing skills I have come to depend on. Vince Aletti and Britt Salvesen are, deservedly, two of the most respected photography writers working today, and I thank them for their beautifully written essays. I am proud to have been able to include their words in this book.

I am especially indebted to Alan Thomas, Editorial Director for Humanities and Sciences, The University of Chicago Press, and to the Press itself, for publishing this monograph. In addition, I thank Alan for his insightful and eloquent contribution to the text. My sincere thanks go to Lanny Silverman, Curator, and Greg Knight, Director, at the Chicago Cultural Center, for their decision to mount the exhibition that accompanies this monograph. My appreciation goes to Ron Gordon, Sandy Steinbrecher, and Christopher Ferrari of Ron Gordon Studio for their help in preparing the prints for the exhibition. I also thank the Illinois State Council on the Arts for its grant in 1999 and an artist's fellowship in 2000, when many of these photographs were made.

Julia and Alan Thomas's enthusiasm for this project has been a driving force from the beginning, and their sophisticated understanding of photographs helped me to clarify my thoughts about these pictures. I owe a great debt to Laura Ferrario, who assisted me during four of my trips to Mexico City. Certainly, many of these photographs could not have been made without her help, and for this, I will always be grateful. Patrick Linehan and I have a deep friendship that began thirty-seven years ago, and I am thankful for his advice and counsel during the long and arduous task of editing this work. As always, I thank my brother, Andy, and my father, Waldo, for their love and support throughout.

Ginny Sykes of Chicago, Joel Goldfrank of New York, and Segretto Partners provided much of the funding for this monograph, and they each have my gratitude. Joel Goldfrank's encouragement greatly helped to further this book. As a discerning collector, Joel has few peers, and I have always admired his most intelligent and refined understanding of photographs. Ginny Sykes has been a collector of my photographs for nearly twenty-five years, and she championed this particular work from the outset. Ginny and I share a common sensibility about art in general and photography in particular, and her generosity of spirit in making me a part of her family, her emotional support, and our wonderful friendship have enriched my life enormously.

Words cannot adequately describe my relationship with Elizabeth McGowan. In Liz, I am fortunate to have a friend whose intelligence and humor are greater than mine, and whose profound insight and love have guided me for close to thirty-five years. Together, we have discovered and rediscovered cities as distant as Rome and Naples, Cairo and Aswan, Mexico City and Mérida. Her remarkable and perfect visual sensibility has informed my work since we first met, and our mutual love and affection have helped me through the best and worst of times. Her effect on my life is immeasurable, and I feel her influence every day.

In 1986, on my first trip to Mexico City, I spent two days photographing in the street. The trip took place less than a year after the worst earthquake in its modern history, but, despite the still-visible damage and customary chaos, I found the city to be vibrant and exciting, the people especially warm and welcoming. One can't help but admire a place where people can scoff at death by naming a subway stop *Barranca del Muerto* (Precipice of the Dead), and calling the small metropolitan buses that run on propane *calderas de muerte* (cauldrons of death) for their propensity to spontaneously combust in traffic. Each subsequent trip to Mexico City to photograph children who could not see was, for me, a profound lesson in beauty, humanity, and vision.

Jed Fielding
2008

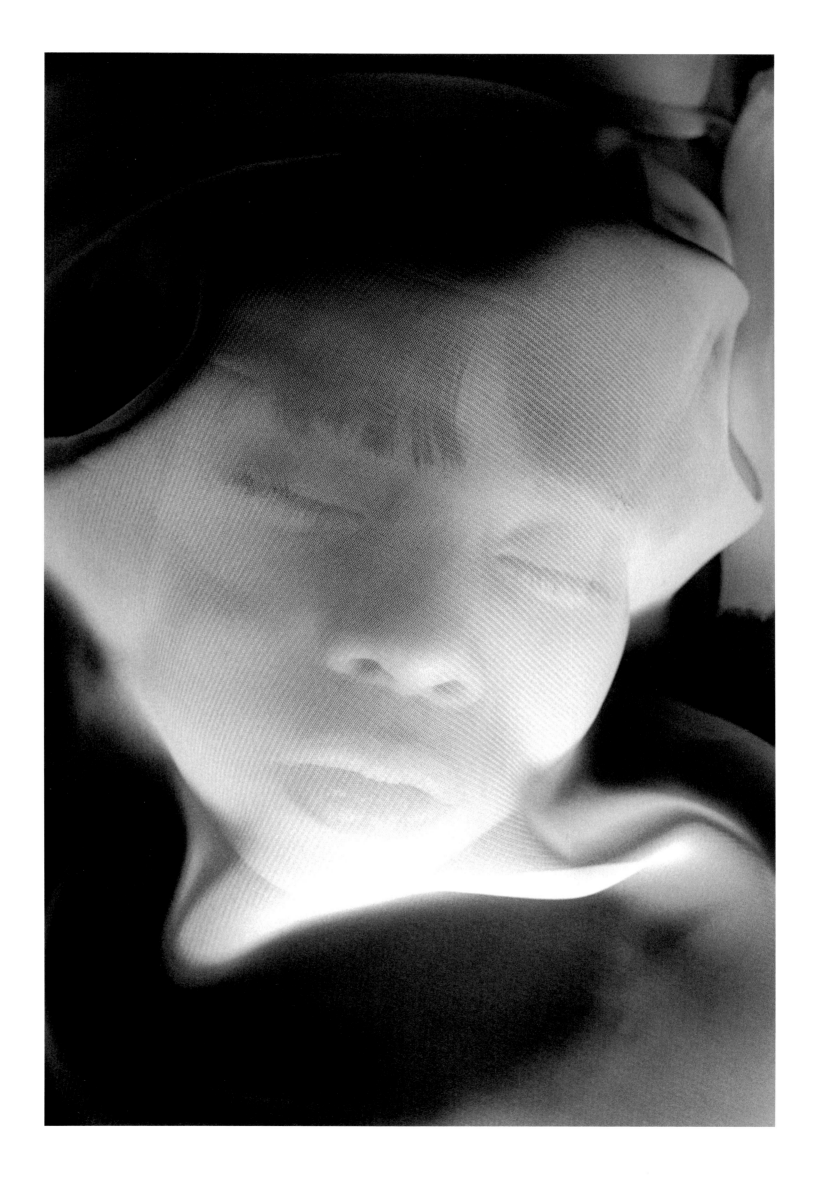

Look at me: Photographs from Mexico City by Jed Fielding
has been published in conjunction with the exhibition of
the same name organized by and on view at the Chicago
Cultural Center from April 11 through July 5, 2009. The
exhibition will then travel.

Jed Fielding studied with Aaron Siskind and Harry Callahan
at the Rhode Island School of Design, then earned his
MFA from The School of The Art Institute of Chicago.
He has photographed extensively in Peru, Greece, Egypt,
Spain, Italy, and the United States and has been photo-
graphing in Mexico for more than thirty years. Fielding's
photographs have been widely exhibited and are repre-
sented in numerous private and public collections.

Britt Salvesen is Director and Chief Curator of the Center
for Creative Photography, University of Arizona, Tucson,
and an adjunct professor of art history.

Vince Aletti, a critic living in New York, reviews photo-
graphy exhibitions for the *New Yorker*'s "Goings
on About Town" section and writes a regular column
about photography books for *Photograph*.

The University of Chicago Press, Chicago 60637
The University of Chicago Press, Ltd., London
© 2009 by The University of Chicago
Photographs © 2009 by Jed Fielding
Foreword © 2009 by Alan Thomas
Introduction © 2009 by Britt Salvesen
Essay © 2009 by Vince Aletti

All rights reserved. Published 2009
Printed in the United States of America
18 17 16 15 14 13 12 11 10 09 1 2 3 4 5

Frontispiece:
Jed Fielding, *Mexico City #135*, 1999

Photograph on page 131:
Jed Fielding, *Mexico City #303*, 2005

Designed by Studio Blue, Chicago
Edited by Terry Ann R. Neff, t. a. neff associates,
Tucson, Arizona
Printed by Meridian Printing, East Greenwich, Rhode Island
Separations by Thomas Palmer, Newport, Rhode Island

Library of Congress Cataloging-in-Publication Data
Fielding, Jed, 1953-
 Look at me : photographs from Mexico City by Jed Fielding
 / Jed Fielding ; introduction by Britt Salvesen ; essay by
 Vince Aletti.
 p. cm.
 ISBN-13: 978-0-226-24852-3 (cloth : alk. paper)
 ISBN-10: 0-226-24852-6 (cloth : alk. paper)
1. Photography of the blind--Mexico--Mexico City. 2. Blind
children--Mexico--Mexico City--Portraits. 3. Fielding, Jed,
1953- I. Salvesen, Britt. II. Aletti, Vince. III. Title.
 TR681.B54F54 2009
 779' .2097253--dc22
 2008031446

This book is printed on acid-free paper.